THE FUNDAMENTALS OF
DRAWING HORSES

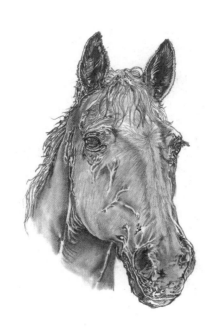

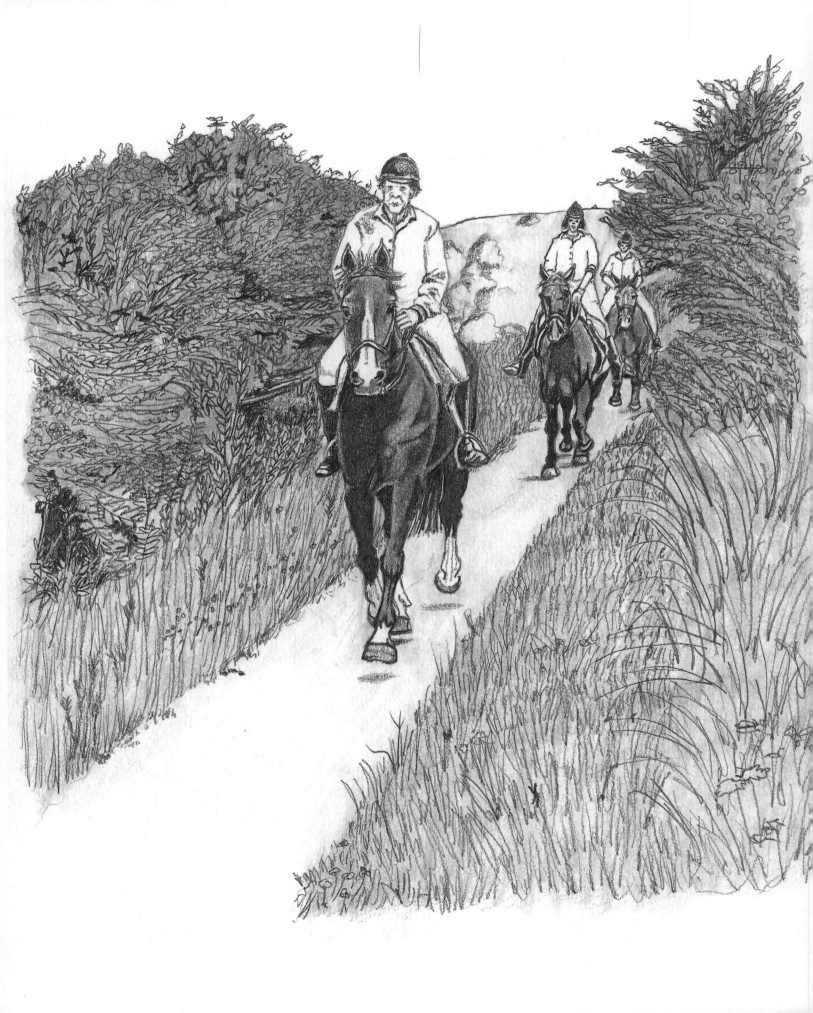

THE FUNDAMENTALS OF
DRAWING HORSES

A COMPLETE STEP-BY-STEP GUIDE

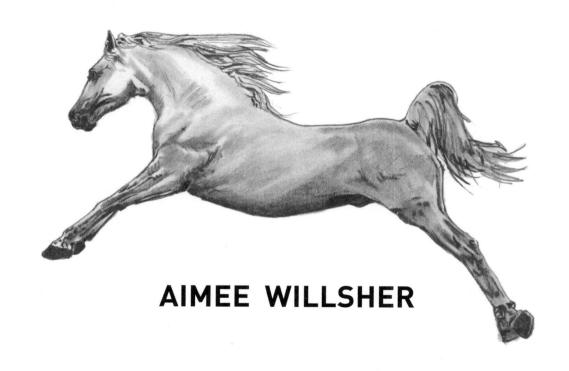

AIMEE WILLSHER

ARCTURUS

ARCTURUS

This edition published in 2022 by Arcturus Publishing Limited
26/27 Bickels Yard, 151–153 Bermondsey Street,
London SE1 3HA

ISBN: 978-1-3988-2128-6
AD003629UK

Printed in China

Contents

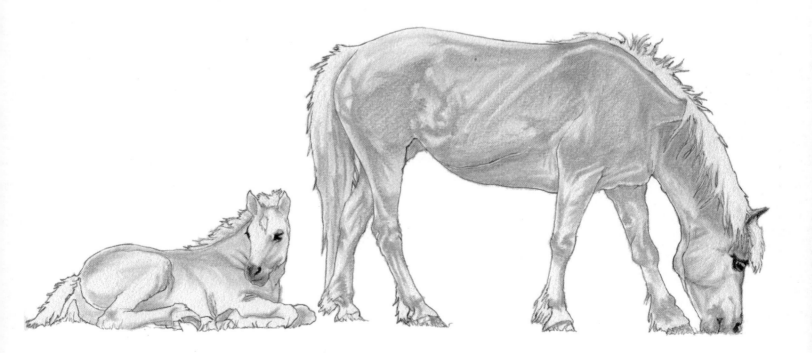

Introduction

The aim of this book is to demystify the process of drawing horses by showing you how to take a systematic approach to what might at first seem a difficult task. Breaking down the complex form and anatomy of the horse into simple shapes that everyone is familiar with makes the initial hurdle of starting to draw reassuringly easy, and you will quickly learn how straightforward it is to use proportional rules to draw visually accurate horses. By following this uncomplicated approach you will learn how to develop your drawings into realistic, life-like pictures.

The book is broken down into six chapters, each of which will lead you through an aspect of equestrian drawing and slowly build your knowledge and confidence so that you'll be able to create ever more complex, diverse and interesting

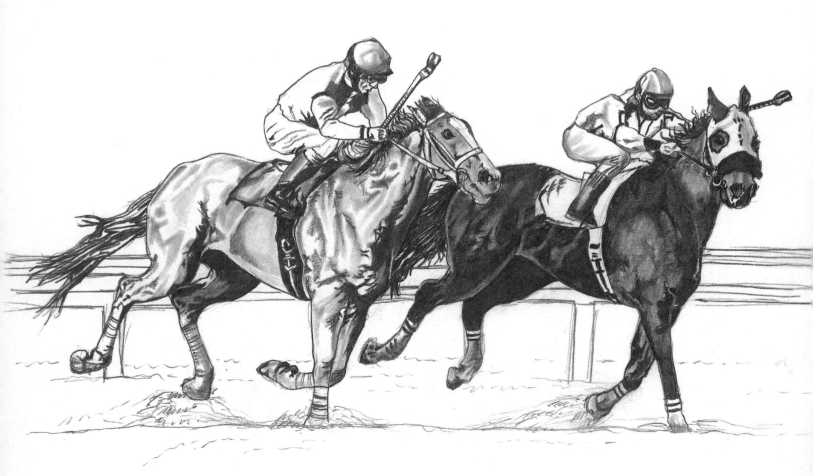

images. Throughout the book, you'll find drawing projects that are broken down into step-by-step images so that you can re-create these projects for yourself by copying each stage. Once you are familiar with how to build and develop simple forms into beautiful, realistic horses you can then begin to create your own original drawings. The guide to the rules of perspective in Chapter 5 will help you to integrate your horses into the landscape and allow you to develop new and interesting compositions with confidence.

Once you have got to grips with the general visual vocabulary needed to create a horse we shall begin to examine the diversity of forms within the species and look at what characterizes a particular breed. This will help you to develop the ability to capture the character and personality of a particular subject and make it individual. At the same time, you will be able to start experimenting with different materials and become familiar with various techniques that will add variety to your work.

Whether you are an absolute beginner or have some experience with drawing, this book will help you to gain an understanding of how to harness your creativity and teach you to develop your own drawing style.

MATERIALS

You do not require a lot of expensive materials to create a beautiful drawing or painting. A few pieces of simple equipment are perfectly adequate when you are starting out and this range can be expanded as you become more confident. All you really need at first is a pencil, a piece of paper and your imagination.

You can draw anywhere, in a field, on a beach or simply in your house. Indoors, a good source of light is important. Daylight is the ideal, so make sure you set up your easel or drawing board in front of a window. When you're working at night or on gloomy days it's a good idea to have both a warm and a cool source of artificial light.

Pencils and pens

Pencils offer an easy way to make a start on more ambitious drawing. They are normally labelled with a letter and a number to indicate the density of the pencil lead – the softer the lead, the darker the mark. Pencils marked with an 'H' are on the harder side of the scale, while those labelled with a 'B' are softer. The number indicates the degree of lead hardness and softness. An HB pencil is in the middle of the range and is a good one to start sketching with. Later, when you start refining your lines and shading techniques, you will want to acquire a range of soft and hard pencils. You will also find a paper stump, or tortillon, useful for blending and softening pencil shading.

Of course there are many other tools for drawing, among them Derwent watersoluble pencils, which are great for shading and then blending with a wet brush. Use an HB pencil for a light wash and an 8B for a dark wash.

Fine-nib ink pens are good for creating clear line drawings. Staedtler waterproof pigment liners are available with nibs measuring from 0.05mm to 1mm, and as the ink won't run it's possible to introduce light washes to the picture. Watersoluble

felt tip brush pens make bold, fine lines and the drawing can then be softened and blended using a wet watercolour brush.

Pastels

Available in the form of a stick or small crayon, pastels are made of pigment powder mixed with a gum binder to give them solidity. They are available in a variety of forms and all are best used on a paper that has a grain or tooth to it as this will provide a good surface for the pigment to adhere to.

Soft pastels have a high proportion of pigment to binder and the colours are therefore bright and intense. They can easily be smudged with a tortillon to create a smooth, subtle blending of tones and hues. When you apply the pastel to your paper some excess dust will form on the surface of your work, so once you have finished your pastel drawing you need to use a fixative to maintain the image. You can buy this from art shops, but hairspray works very well as a substitute.

Hard pastels have a high proportion of binder to pigment, which means that the pastel stick is harder and the end

can be shaped into a point. This makes them useful for creating finer details that cannot be achieved with soft pastels. Hard pastels are also available in a pencil form. These are very easy to handle and sharpen, making them a good way to start exploring the use of pastel as a medium.

Oil pastels have a soft, buttery consistency and like soft pastels they have a high proportion of pigment to binder. The oil pastel stick is very dense and when rubbed on the paper the pigment sticks fast, so they are more difficult to blend than other pastels.

Charcoal and chalk

These can be combined to produce high-contrast images. The charcoal creates a dense, dark tone, which can be heightened by highlights of white chalk.

Paint

Watercolour, gouache and acrylic paint can be used to make beautiful grisaille studies, following in the footsteps of the Renaissance Old Masters.

Brushes

Paint brushes are available in a variety of sizes and bristle textures, and it is important to select the right brush for the task in hand. Small, round-tipped sable brushes are good for creating fine detail or light washes. For thicker acrylic paint it is better to use a heavier-bristled, more robust brush, made of either hog hair or synthetic nylon.

Paper

It's best to use paper specific to the materials you intend to work with. For simple pencil sketches a medium

to lightweight paper is fine (around 135gsm/90lb). When water blending is introduced to a drawing a more robust paper will allow you to produce the best effect. I like a heavyweight 200gsm (120lb) acid-free paper when using light washes in a drawing. This paper is very versatile and can be used for pen and ink, chalk and charcoal drawings.

When you want to progress to a fully worked watercolour an even heavier paper is needed to withstand the effects of the water and paint. A good choice is 300gsm (140lb) Bockingford paper, which is beautifully textured and absorbent – it will not wrinkle or change shape.

Textured charcoal and pastel paper can be used to add depth to a drawing. The tooth of the paper also helps to retain and preserve your marks. These papers are available in a range of colours that give you a mid-toned surface to work on.

A few bound sketchbooks, which are available in a range of sizes, are great for gathering visual ideas together in one place. The paper does not need to be high quality.

Accessories

A sharp pencil is important so that you can create a precise fine line. A craft knife is preferable to a pencil sharpener as you can shape the lead more accurately to suit the job. A kneaded putty eraser allows you to remove precise areas of shading, as small pieces can be shaped into wedges and points for accurate erasing. For erasing large areas of shading, a simple vinyl eraser is effective, removing pencil marks completely. Make sure you erase gently and sparingly so as not to damage the paper.

BASIC TECHNIQUES

While making an accurate outline of a horse is the starting point for a good drawing, the animal only becomes convincingly three-dimensional when tone is put in to show the contours of its body. There are various ways of applying tone, and which you choose will depend on the medium you are using and the effect you want to create.

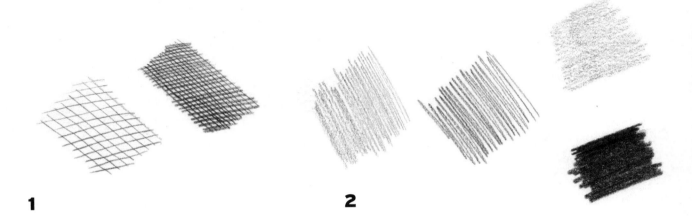

1

2

1. Cross hatching

This technique is a method of creating tonal contrasts and shading by drawing closely spaced parallel lines over an area then putting in more lines over the top of them at the opposite angle. As the dark tone is not flat, cross hatching adds texture and interest to shaded areas. To vary the darkness of tone, simply vary the spacing between the lines – the closer the spacing, the darker the tone.

Cross hatching is best executed with a fine-nibbed pen or propelling pencil. Both produce a fine, clear line that is perfect for the technique.

2. Shading

Almost any medium can be used to create shading, so your choice is wide here. Just working with a variety of graded pencils from hard to soft will produce a huge range of dark and light tones which can then be made smooth and soft by blending with a tortillon.

How you hold your pencil and the pressure you apply to make your marks also has an effect on the appearance of your shading. Holding the pencil at an oblique angle to the paper creates a smooth, soft texture to the shading, while keeping it perpendicular makes distinct lines within the body of the shaded area. Pressing hard on the paper with the pencil lead creates dark, dense tones.

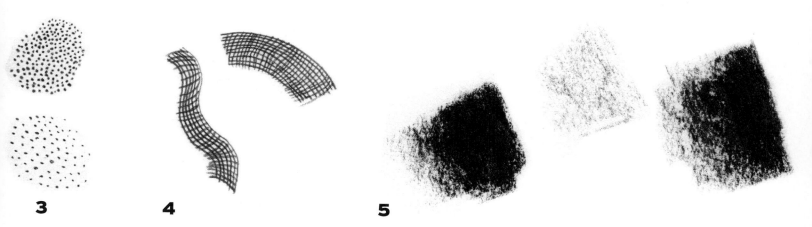

3 **4** **5**

3. Pointillism

A versatile technique which can be created with a variety of mediums including paint, pencil and ink, pointillism was originally developed in the late 19th century by the French artists George Seurat and Paul Signac as a way of applying colour. The key to creating a pointillist effect is making numerous small distinct dots on your picture surface to establish tone and textural interest. As with cross hatching, the spacing of the dots will dictate the depth of tone.

4. Contour lines

This method of toning performs a dual function as it also describes the form of an object, with curved lines indicating a curved surface, for example. Planning the direction of your contour lines is essential to make them work effectively.

5. Pastel scumbling

Scumbling is a technique where two tones are layered one over another, with the top layer translucent enough for the bottom one to be still visible. This technique is interesting because it confuses the eye into thinking the two unmixed tones are one. A huge variety of effects can be had within the scumbling technique, and it creates beautiful depth in a picture. Whether you are laying light over dark or vice versa, it is important to apply the top layer lightly and sparingly so that the base tone is not completely covered. You can even blend parts of the scumbled surface to add further variety to the surface of the picture.

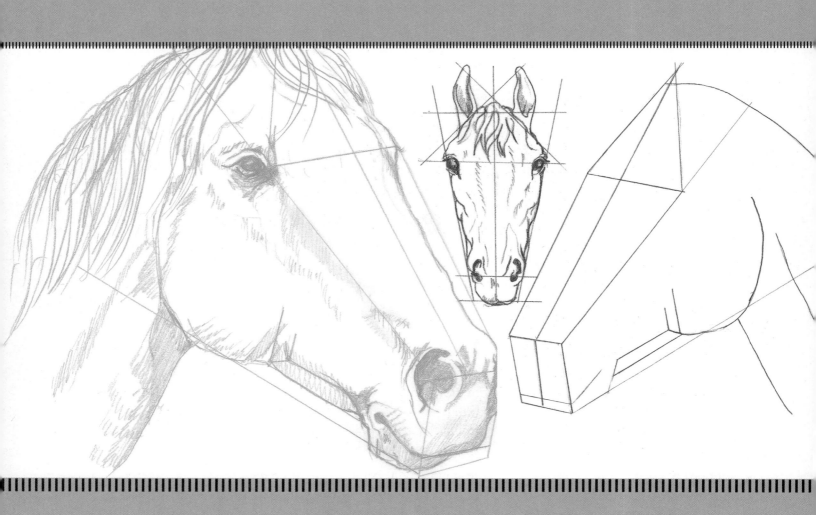

Basic Anatomy, Form and Proportion

An animal's anatomy dictates its form, so when you are starting to draw any species it is helpful to have a grasp of its basic structure. An understanding of the composition of the skeleton and muscles makes sense of the form that you can see.

The next step is to simplify shapes and construct simple drawings, following some basic formulas. Tackled in this way, drawing a horse becomes easy.

Proportion and shape vary from breed to breed and the guidelines in this chapter are just a starting point that can be refined and adapted according to the individual subject, enabling you to evolve your personal style.

ANATOMICAL DRAWINGS

The diagrams here are of a horse at a gallop. Fig. 1 shows the bone structure, which has been pared down in Fig. 2 to show the basic sizes and shapes of the bones. Familiarity with the overall shape of the skeleton and how the bones give the body form will increase your visual sensitivity to your subject and help you to produce a visually accurate drawing.

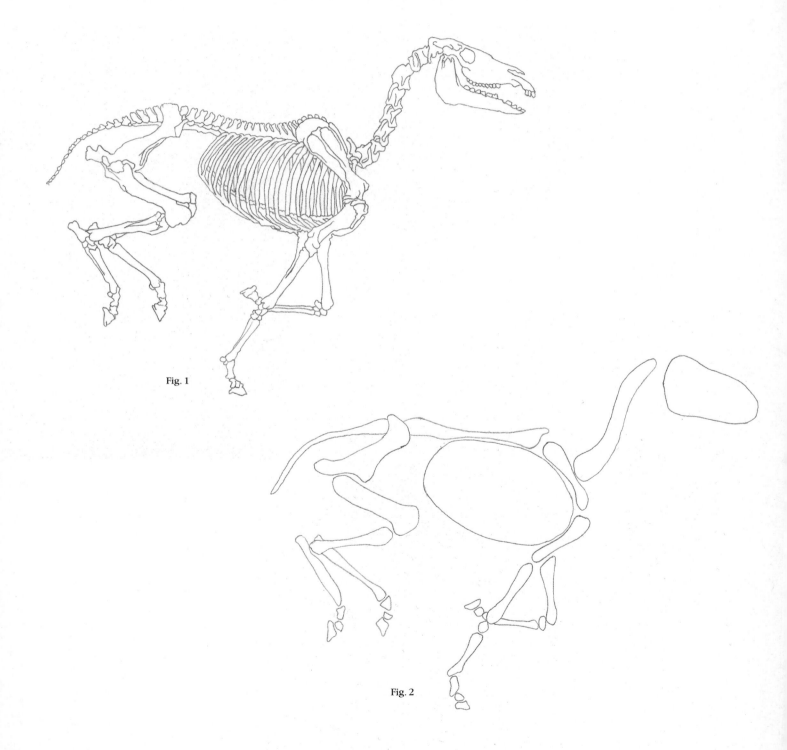

Fig. 1

Fig. 2

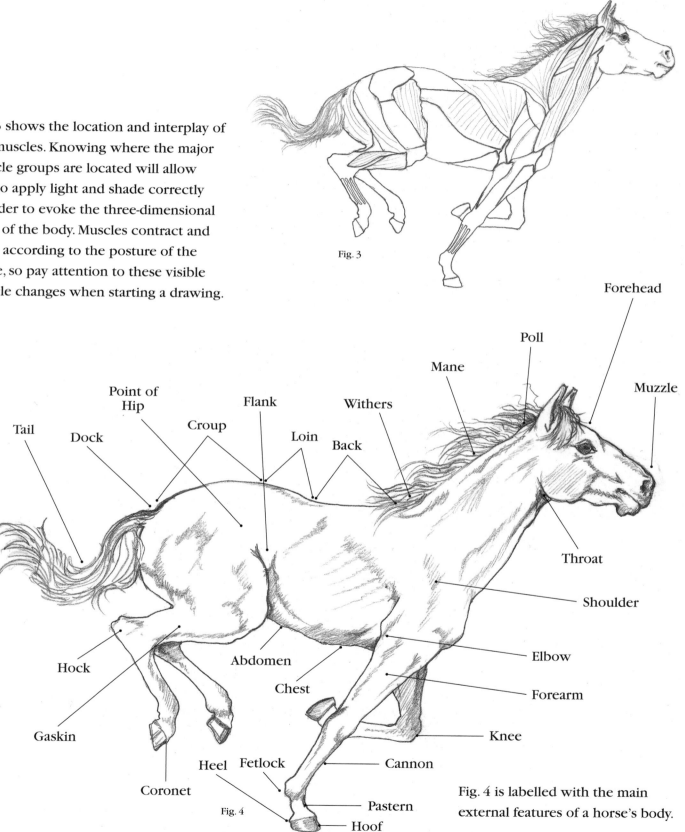

Fig. 3 shows the location and interplay of the muscles. Knowing where the major muscle groups are located will allow you to apply light and shade correctly in order to evoke the three-dimensional form of the body. Muscles contract and relax according to the posture of the horse, so pay attention to these visible muscle changes when starting a drawing.

Fig. 3

Fig. 4 is labelled with the main external features of a horse's body.

Fig. 4

Tail
Dock
Point of Hip
Croup
Flank
Loin
Back
Withers
Mane
Poll
Forehead
Muzzle
Throat
Shoulder
Elbow
Forearm
Knee
Cannon
Pastern
Hoof
Heel
Fetlock
Coronet
Gaskin
Hock
Abdomen
Chest

USING SIMPLE SHAPES

The horse is a complex form and each animal has its own individual appearance. Breaking the horse down into simple shapes that we are all familiar with can make starting a drawing less daunting. Fig. 1 shows a horse described as a series of primary shapes. The hard, angular outline can then be softened and the shapes erased to leave behind a realistic-looking form. You can apply the same method to a horse in any position (Figs 2 and 3). Fig. 4 shows the softened outline.

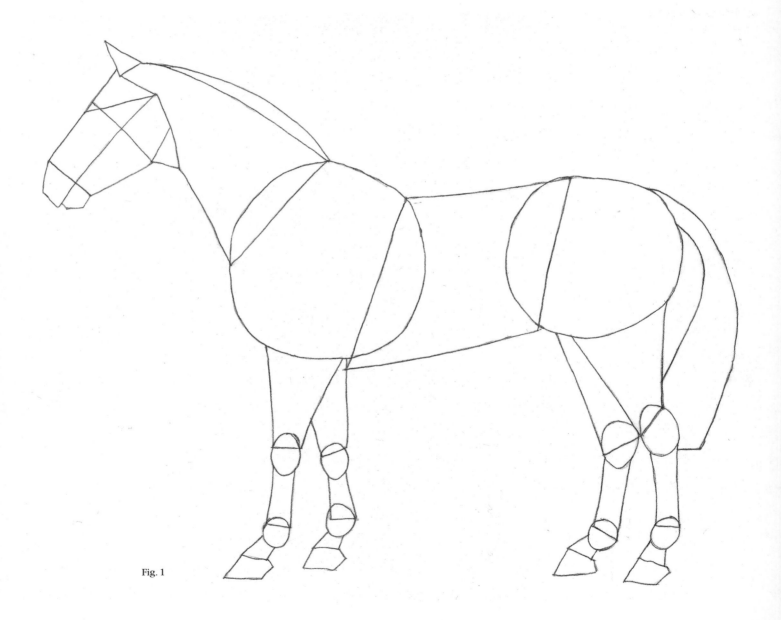

Fig. 1

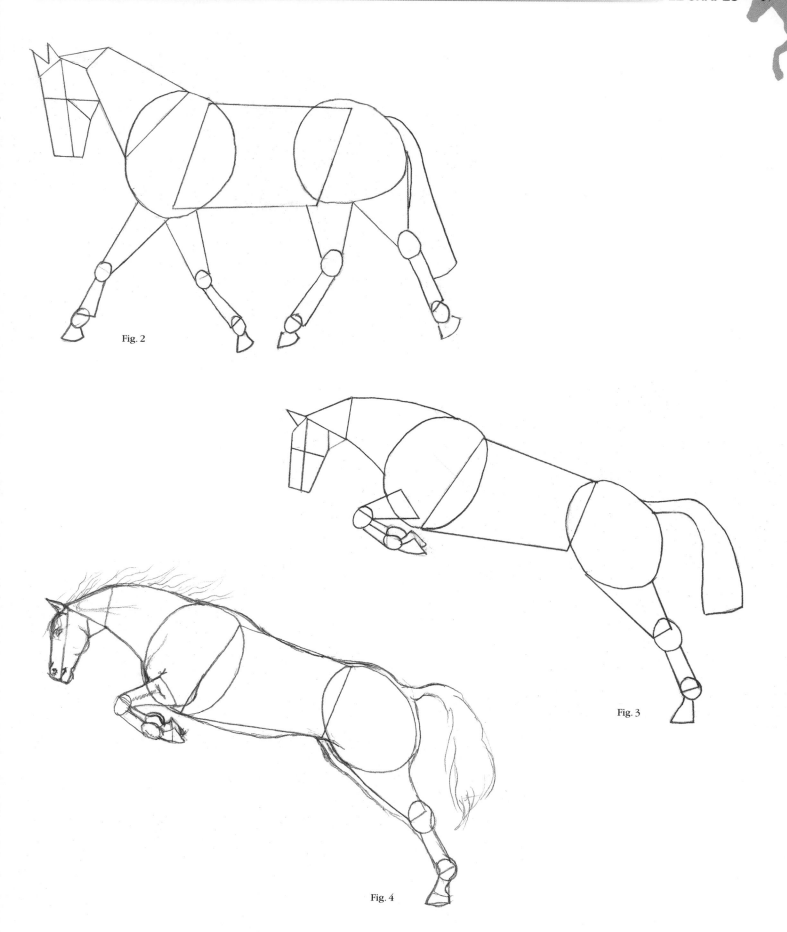

Fig. 2

Fig. 3

Fig. 4

THE HEAD

It is simple to draw a horse's face, both in profile and front on, within a coffin-shaped network of lines. In Fig. 1, lines bisect the coffin horizontally and vertically. The horizontals show the correct placement of eyes and nostrils, and the diagonals that cross at the top determine the length and position of the ears. The vertical helps to maintain symmetry in the face when the shading is added.

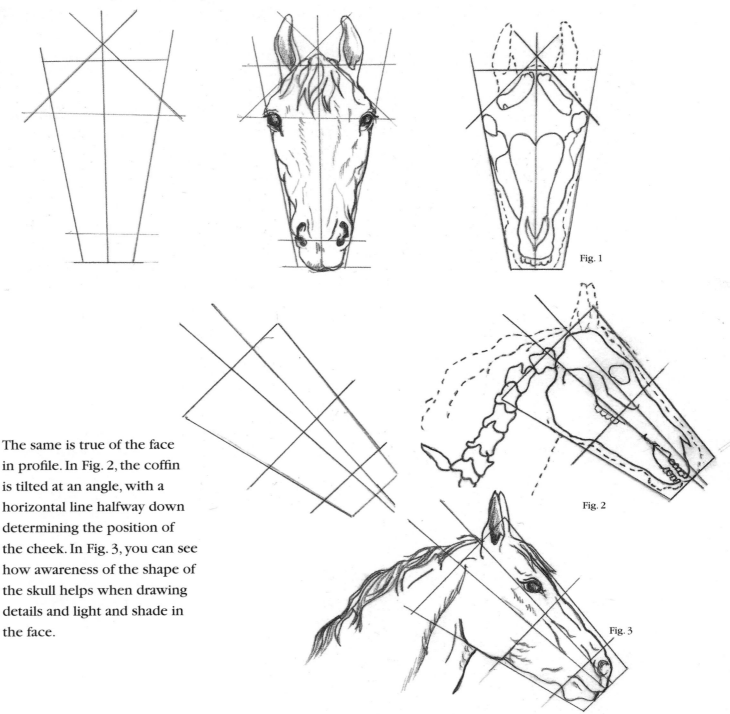

Fig. 1

The same is true of the face in profile. In Fig. 2, the coffin is tilted at an angle, with a horizontal line halfway down determining the position of the cheek. In Fig. 3, you can see how awareness of the shape of the skull helps when drawing details and light and shade in the face.

Fig. 2

Fig. 3

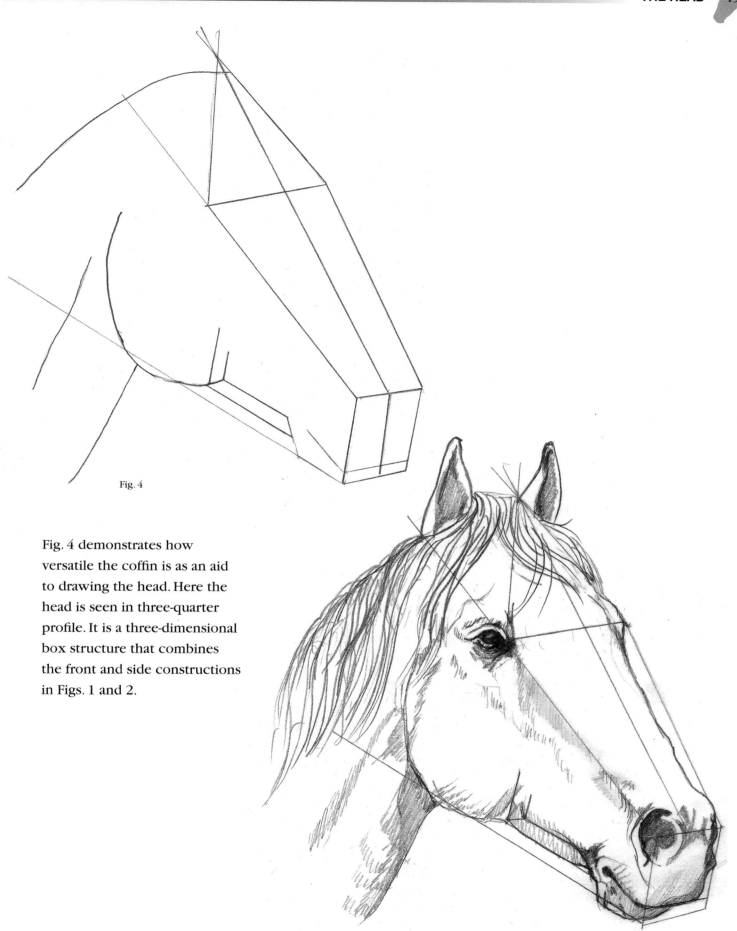

Fig. 4

Fig. 4 demonstrates how versatile the coffin is as an aid to drawing the head. Here the head is seen in three-quarter profile. It is a three-dimensional box structure that combines the front and side constructions in Figs. 1 and 2.

ESTABLISHING PROPORTION

We all know that a horse has a head, body and four legs, but it's getting the relative proportions right that really makes a drawing conjure up the essence of the animal. Following a few simple guidelines will help you at first, but you won't have to rely on these rules forever as in time you'll develop a natural feel for the relationships between the parts of a horse's body.

Of course, proportion will change depending on the horse's position and the angle from which it is viewed. It's important to look carefully at your subject and adjust the proportional guidelines accordingly.

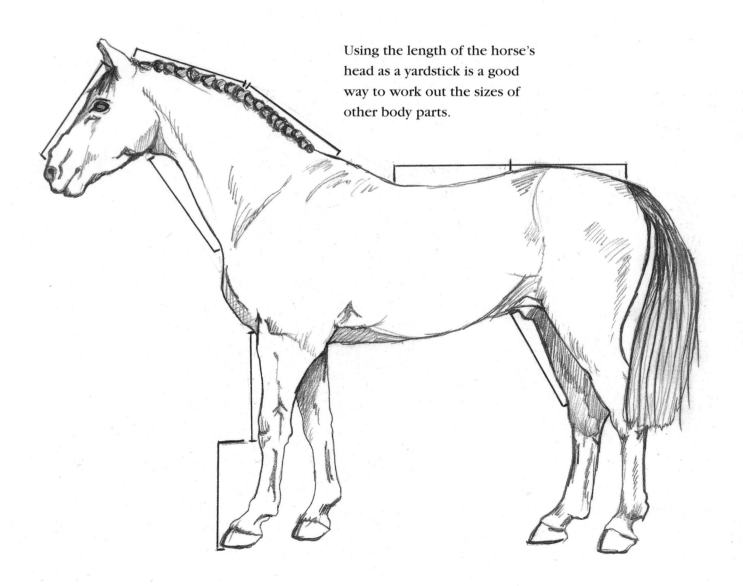

Using the length of the horse's head as a yardstick is a good way to work out the sizes of other body parts.

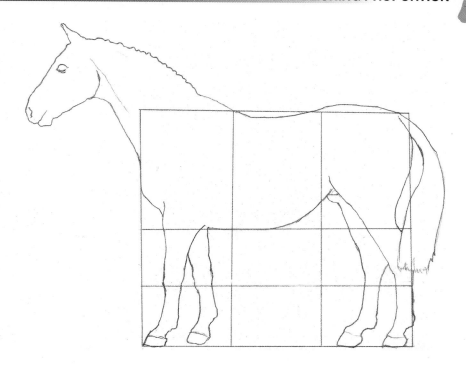

The horse's legs and body fit into an approximate square.

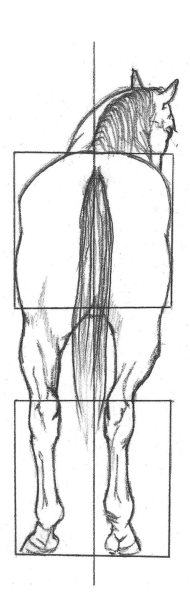

The rear and front body will fill a square. A square of the same size can be used to work out the length of the legs from the knee and hock to the bottom of the hooves.

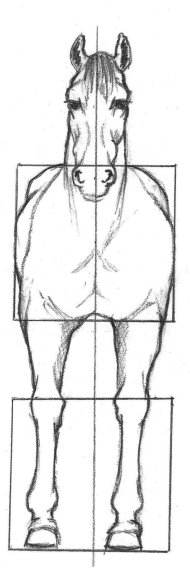

SKETCHING FIRST IMPRESSIONS

Now that you have an understanding of equine anatomy, form and proportion it's time to start applying your knowledge and experimenting. Using photographs, paintings, drawings and sketches for reference is a good place to begin, since making studies from a static image is great to build your confidence and familiarity with form and posture. When you feel ready, start looking at the world around you. Fortunately, you don't have to live in the countryside to see horses in the flesh; they are working animals and can frequently be seen on city streets as police horses or at riding schools near public parks.

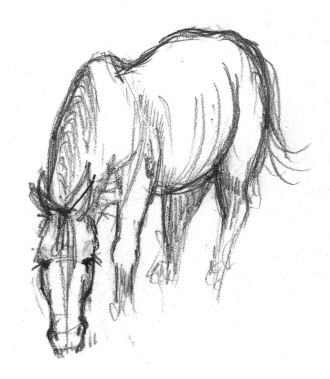

Don't let the theory you have learned put you off starting to draw spontaneously. While anatomical and proportional accuracy are important, they aren't the only factors to think about. Fast, vigorous sketches are a brilliant way to loosen you up and fuel your enthusiasm and creativity. These studies are quick to create and are therefore a perfect way of drawing from a live subject that doesn't stay still for long! They can exist as works in their own right or act as a visual reference from which to develop a detailed drawing or painting. Working spontaneously will ultimately allow you to inject personal style into your finished drawings.

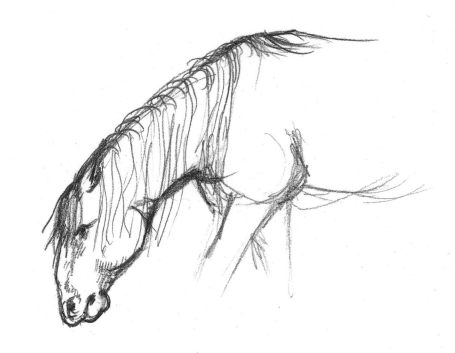

The sketches here are of some
horses that live at a riding stable
close to my house. I allowed myself
only a couple of minutes per sketch.
They are by no means accurate,
but they express the energy with
which they were created. As your
drawing develops, take elements
from both approaches and try to
combine the looseness of your
sketches with the accuracy of
the proportional drawing in your
detailed completed works.

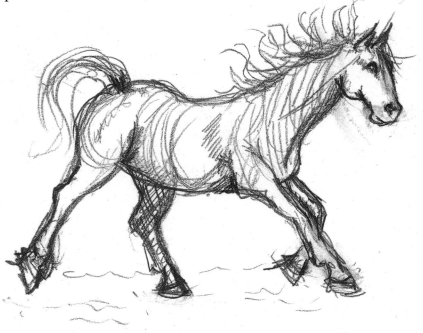

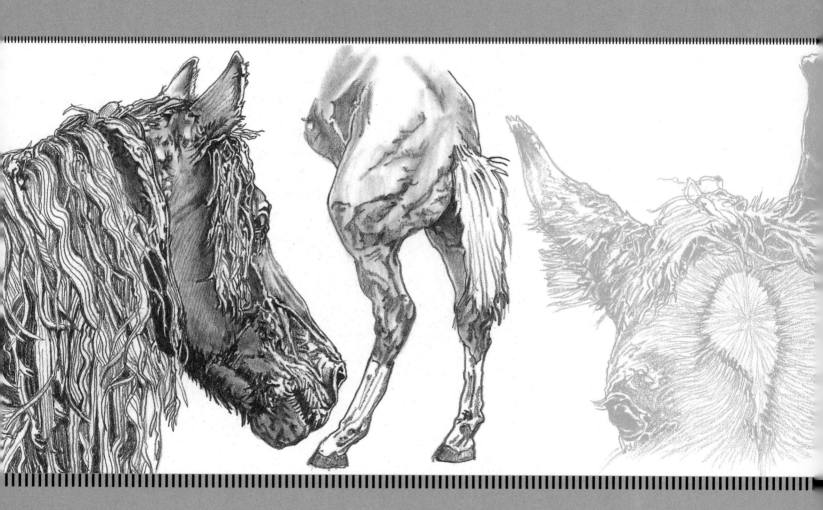

Capturing Detail

Now you've discovered how to create accurate drawings of horses, it's time

to make your work come alive. Learning how to capture detail and focus on

important distinguishing features will enable you to convey the essence of an

individual horse. The eyes, ears and muzzle vary greatly from horse to horse

and all convey the animal's mood. You already understand how the features

of a human face express sleepiness, anger, interest and so on; in this chapter

you'll find out how to interpret the horse's facial expressions too.

The horse is a herd animal, each with a position within the hierarchy, and

communicates largely through body language. Portraying expression through

accurately drawing the details of a horse will help you to create emotive

compositions of horse interaction.

THE EYE

The horse has the largest eyeball of any land mammal; this acts like a big magnifying glass, enabling it to see distant objects very clearly. The eye is surrounded by long lashes and covered by a mucus membrane called the third eyelid, both serving to protect this highly specialized sensory organ.

The step-by-steps here are of the two most important views of the eye: from the front and from the side. Once you have mastered the structure of each view you can adapt it to fit a variety of head angles.

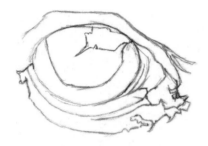

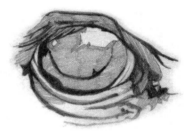

The side view
STEP 1

I started by drawing a large oval and added the eyelid detail above and below. I marked out the circle of the iris, the pupil and an area that would become a highlight. When drawing fine outlines I like to use an HB propelling pencil with a 0.5mm lead, which makes a clear, fine line. Propelling pencils maintain their fine point so you don't have to pause to sharpen them.

STEP 2

Next I lightly shaded in the pupil and iris with an HB light wash Derwent watersoluble pencil. I darkened the corners and the lines suggesting the creases of the skin surrounding the eye. Adding the eyelashes, I started them about halfway across the eyeball and flicked them into the far corner of the eye, ensuring the highlight was left white so that it would stand out in the finished drawing.

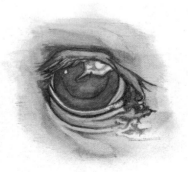

STEP 3

Using a No. 1 round watercolour brush, I blended the shading so that it was subtly graduated. Finally, I darkened the pupil and iris further using an 8B dark wash watersoluble pencil, which I then blended with the wet brush so that the highlight is really thrown into contrast.

The front view

STEP 1

Once again, a line drawing was the basis and I constructed this using my 0.5mm propelling pencil. I began with a circle that tapers into the right corner, surrounded this with the eyelid detail, then sketched in the lines of the head. Notice how the bone surrounding the eye socket protrudes from the side of the horse's head and the curve of the eyeball can be seen in profile. I added the eyelashes and extended them past the edge of the drawing.

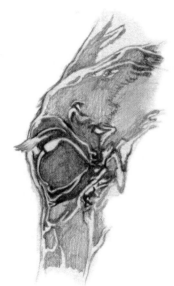

STEP 2

I lightly shaded in the area surrounding the eye using the HB light wash watersoluble pencil, remembering to leave highlights to describe the projection of the eye socket and eyelid.

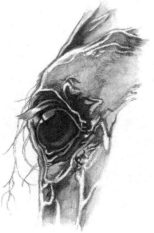

STEP 3

Using a No. 1 round watercolour brush, I blended the light wash shading. I used the 8B watersoluble pencil to establish the darkest tones of the eye and then blended again, using the wet brush. Finally, I added a few strands of hair to set off the profile line on the drawing.

THE EXPRESSIONS

The methods used to draw the eyes on the previous pages can be adapted to show the mood of the horse. Expression in the eye is basically affected by the muscles that surround it. These muscles contract or relax and change the shape of the eyelids, revealing more or less of the eyeball. In a relaxed, friendly or sleepy horse the muscle definition will be soft, while in an angry, scared or alert horse the muscles around the eye contract and appear taut. The edges will be well defined.

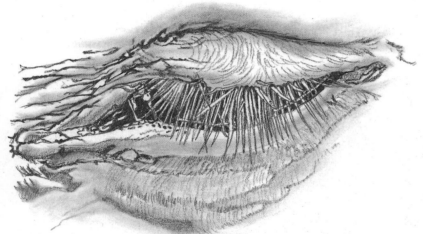

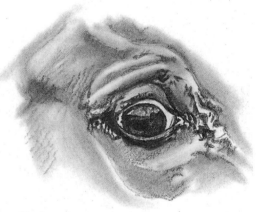

Fig. 2

Fig. 1

Fig. 1 shows the eye half closed – everything about the expression is calm, tired and sleepy! The shading which suggests the muscle tone is softly graduated.

Figs 2 and 3 show the alert eyes. The stark contrast between dark and light tone evokes the tautness of muscle present beneath the skin. The white of the eyeball is visible; this heightens the drama and intensity of the expression.

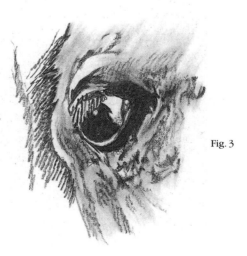

Fig. 3

THE EAR

The ears are probably a horse's most expressive body part, their position clearly showing what it is feeling. These simple drawings describe the code of ear signals.

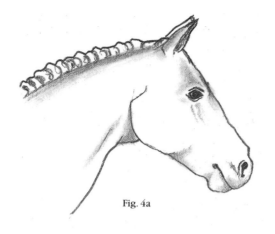

Fig. 4a

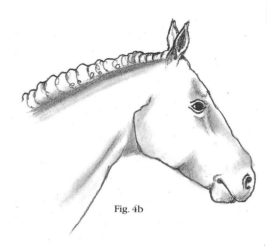

Fig. 4b

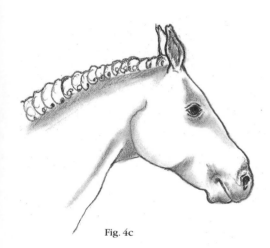

Fig. 4c

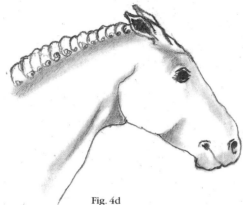

Fig. 4d

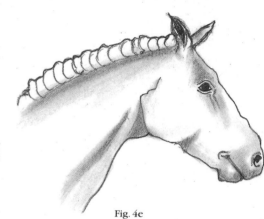

Fig. 4e

In Fig. 4a the ears are upright and pointing forwards, indicating intense interest in something seen or heard up ahead. In Fig. 4b they are upright but divided, pointing in opposite directions; this horse is alert, ready to perceive the goings on in the immediate area. The horse in Fig. 4c shows submission or slight concern; the ears are drawn back slightly, showing it's alert but a little unsettled. When the ears are pinned flat to the head as in Fig. 4d, the horse is demonstrating anger, aggression or irritation. In Fig. 4e one ear points forwards while the other is directed towards the rear of the horse, indicating either extreme fear or simply divided attention. Fig. 5 shows a detailed drawing of the ears in this position.

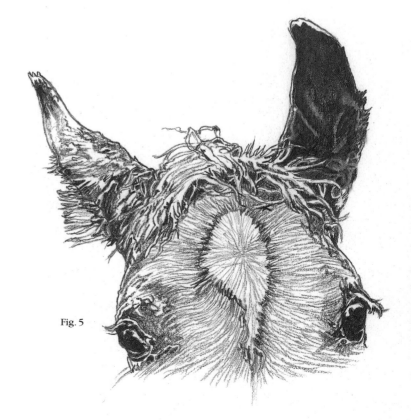

Fig. 5

The ear step-by-step

Now that you know how to interpret the meaning of a horse's ear positions it's time to begin using these expressions in your finished drawings to establish mood and character in your pictures. The step-by-step drawings will help you to get started.

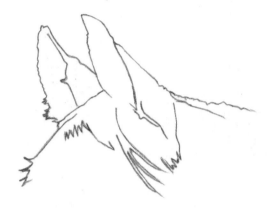

STEP 1

This drawing shows alert ears seen in three-quarter profile. I started by looking at the photograph of the ears and simplifying the shapes in my head. The ear is basically a three-dimensional triangle. These very simple lines will give you a correctly shaped framework. For this initial stage I used my propelling pencil to achieve a clear fine-lined structure upon which I could build throughout the drawing stages.

STEP 2

I paid close attention to the curve and variability of the lines and softened the straight edges to create a more realistic shape. After I had roughly planned the placement of the forelock and tufts of hair around the ear the basic framework could be erased.

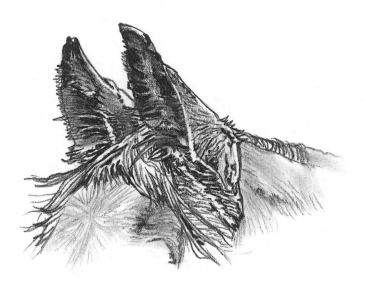

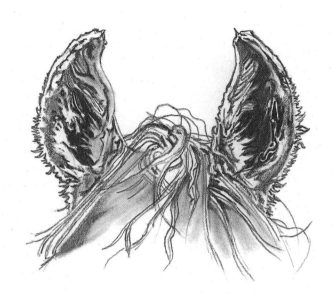

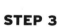

STEP 3

Next I shaded the line drawing to create substance and texture, showing how the hair of the forehead radiates from a central point. For this I used a softer 2B pencil with a slightly blunt point so that my shading would be soft and smooth. I darkened the insides of the ears, then lightly shaded the surrounding neck and the backs of the ears and smudged them softly with a tortillon. Then I added lines to represent the hairs of the forelock.

Here are two other detailed drawings of the ears, still alert but seen from a different position. Once you have followed the step-by-step of the first position, you shouldn't have much difficulty in drawing these on the same principles.

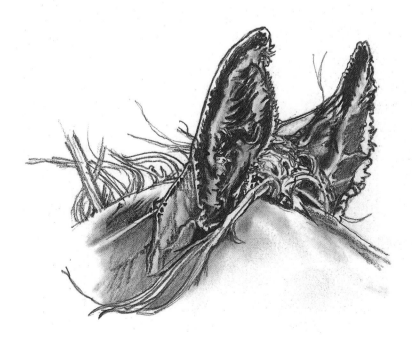

THE MUZZLE

The horse's muzzle is extremely muscular and both practical and expressive. It is essential in the process of grazing, the lips enabling the horse to grip and tear up the blades of grass. Understanding the power and shape of these highly developed muscles will help when creating your drawings. As a general rule, the more relaxed the muscles of the muzzle, the more content and sleepy the horse.

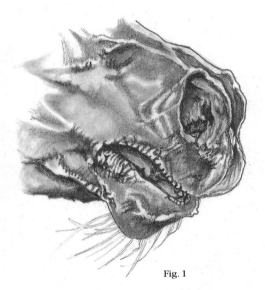

Fig. 1

In Fig. 1 the horse's mouth is slightly open, the top lip protruding forwards. The nostrils are defined, suggesting deep inhalation, and the entire musculature is taut. This horse is alert and moving.

Fig. 2 shows the muzzle seen from the front. The nostrils are wide, ready to sniff out a change in the environment.

The comical expression in Fig. 3 is characteristic of a stallion trying to detect the scent of a mare on heat.

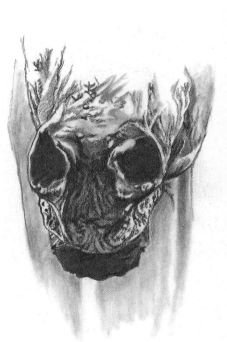

Fig. 2

Fig. 3

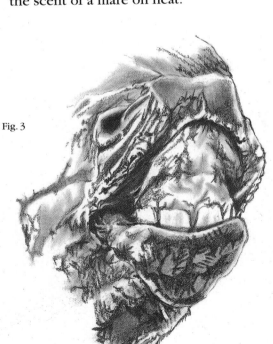

The muzzle step-by-step

This demonstration shows how to draw the muzzle seen from the side. It is relaxed, with the bottom lip hanging down – this horse is obviously a bit sleepy.

STEP 1

Using my propelling pencil, I started my drawing by constructing the basic coffin shape we looked at in Chapter 1 and then planned the location of the lips and nostrils using straight bisecting lines.

STEP 2

Next I softened the straight lines and added line details to refine the shape of the nostrils and locate muscle definition.

STEP 3

Once I was satisfied that everything was in the correct position I shaded the darkest areas using a regular 2B pencil and defined the skin wrinkles.

STEP 4

Using the same 2B pencil, I lightly shaded the rest of the muzzle, leaving light areas to suggest the projections. I softened and blended this shading with the tortillon. Finally, I worked on creating details and texture in the drawing. The soft flecks below the nostril suggest hair follicles, while the contrast of dark and light lines around the corner of the mouth indicates the soft wrinkles in the skin.

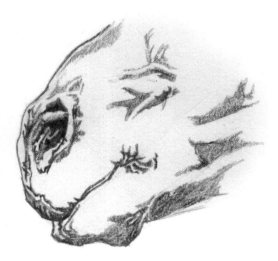

OTHER KEY DETAILS

Horses have many different variations of colour, texture and pattern in their hair. Familiarity with these variations can help you to determine the breed and even the age of the horse.

The details here demonstrate techniques that can be used to create texture. They show the mottled pattern of the dapple grey, the distinct spots of the appaloosa, the small flecks of the fleabitten grey and the black or brown and white patches of the piebald or skewbald horse.

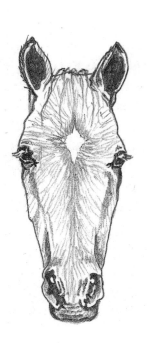
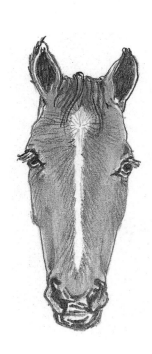
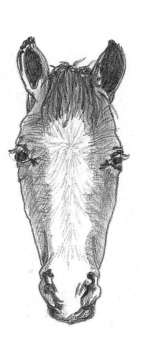

Here we can see the variations of facial marking within horses. A horse's face may be uniform in colour, but it's common to see white hair in the shape of a star, blaze, or stripe.

Mastering the drawing of the mane and tail can really add dynamism to an image of the horse in motion, their fluidity and freedom accentuating the feeling of speed.

These quick studies of legs reveal a glimpse of the variation of position and angle. You can master the form of the legs using the simple shapes shown in Chapter 1. To achieve a realistically toned leg, pay attention to the shading to evoke the bone, tendon and muscular structure beneath the skin.

COMBINING FACIAL DETAILS

Once you are familiar with the techniques and processes needed to create the eyes, ears and nose you can begin to attempt detailed finished drawings, combining what you have learnt in Chapter 1 about constructing a proportionally correct head.

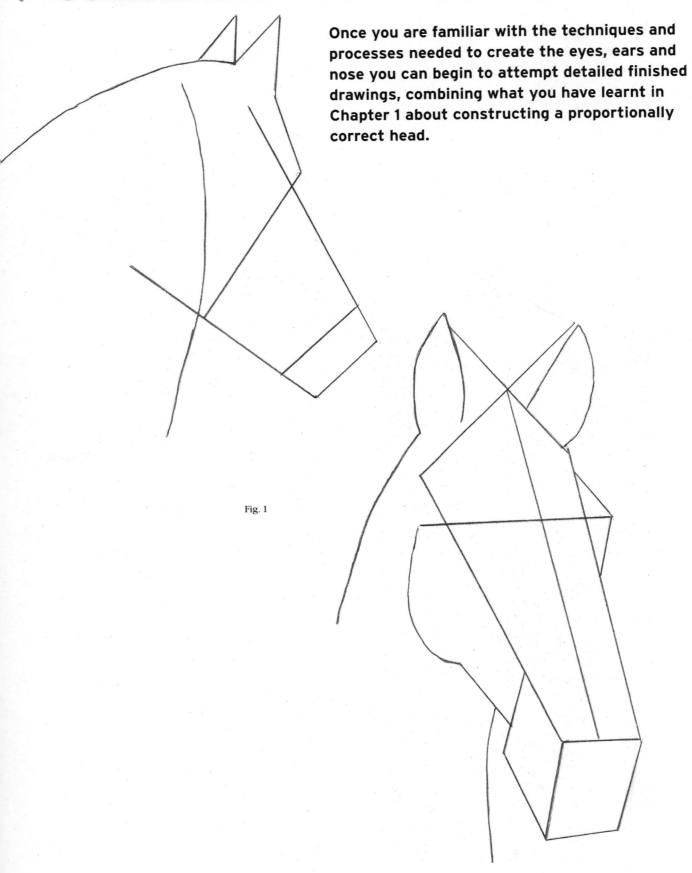

Fig. 1

Fig. 1 shows the simple line constructions which make starting the drawing less daunting, while Figs 2 and 3 show finished drawings of a horse's head in two different positions. The drawings combine the techniques explored throughout this chapter. The ears, eyes and nose all interact to evoke an expression and the texture of the hair and subtle tonal variation help to explain the form of the face, denoting the bone and muscle projection.

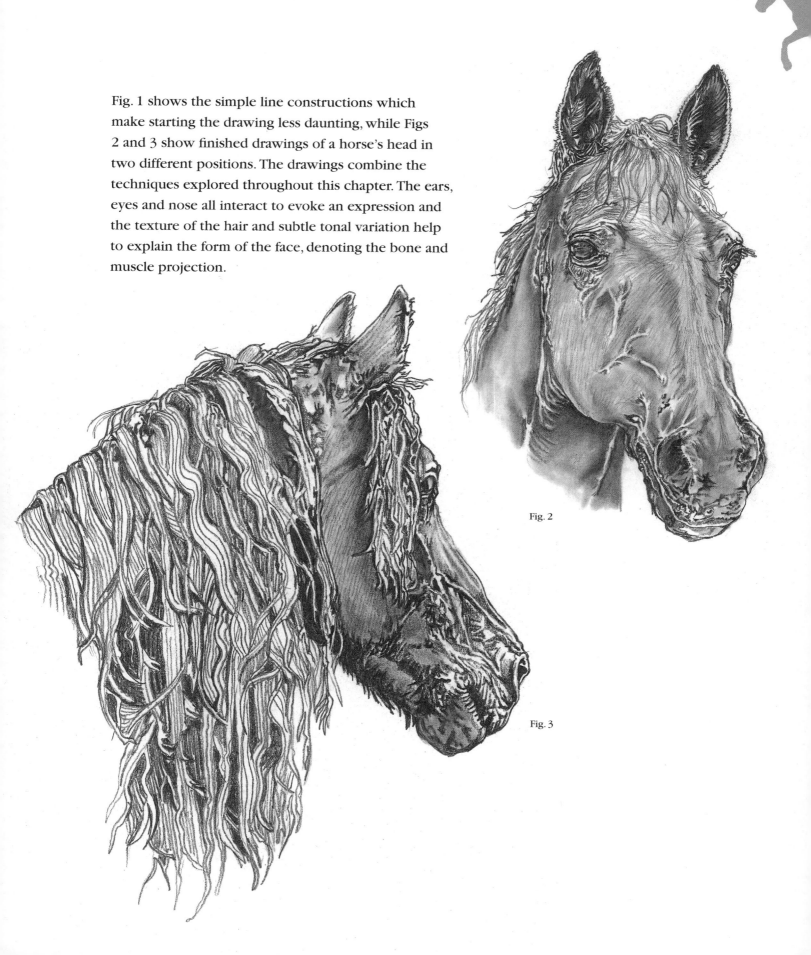

Fig. 2

Fig. 3

COMBINING BODY DETAILS

All the details we have looked at throughout the chapter are combined in this final detailed drawing of a standing horse. The step-by-step details show how the separate elements have been created.

Injecting detail into a drawing isn't difficult. Tackling each element separately and in simple stages allows you to familiarize yourself with the forms and processes that need to be completed to reach your finished detailed horse drawing.

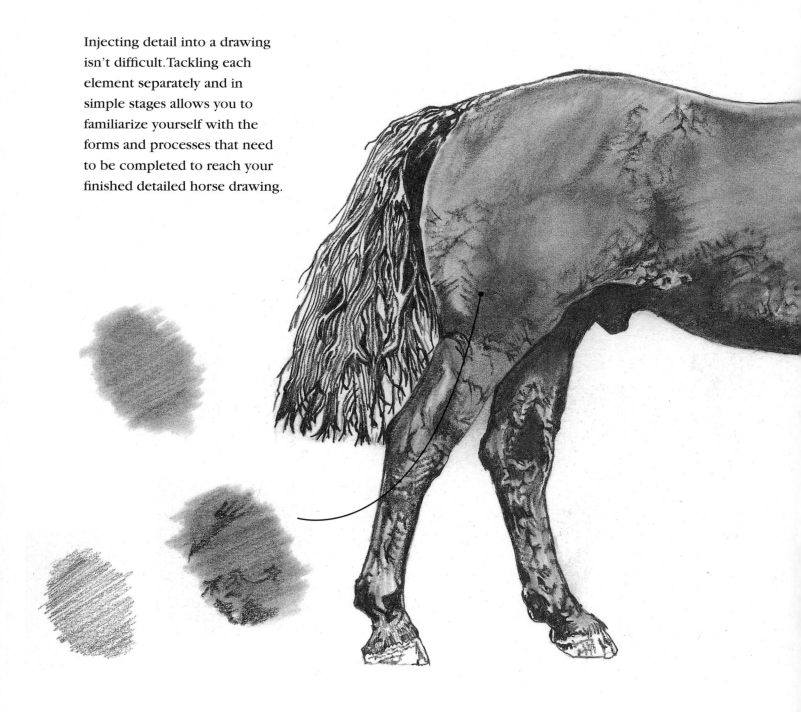

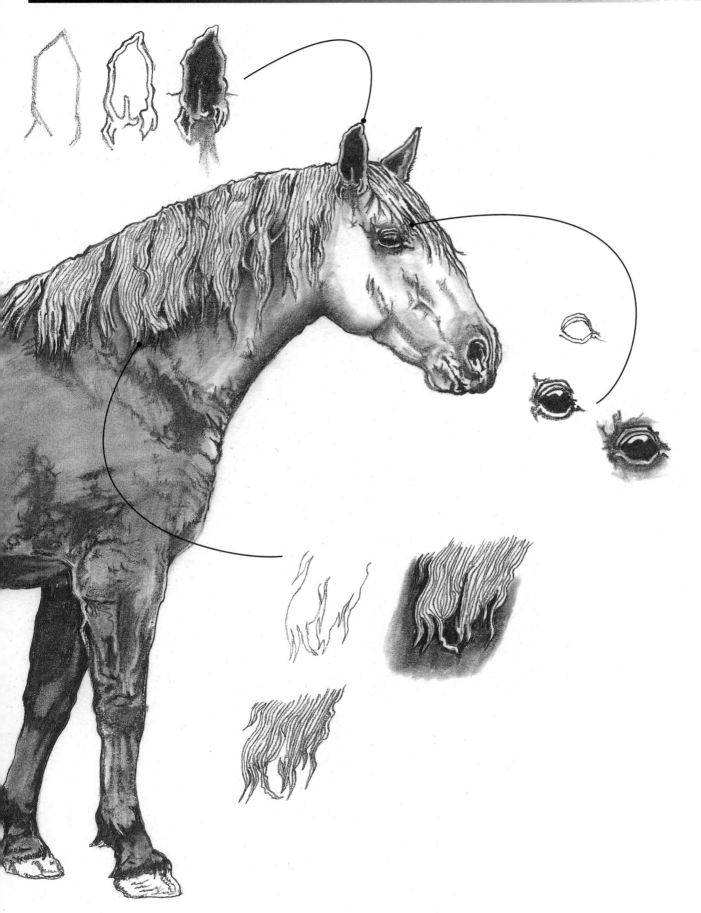

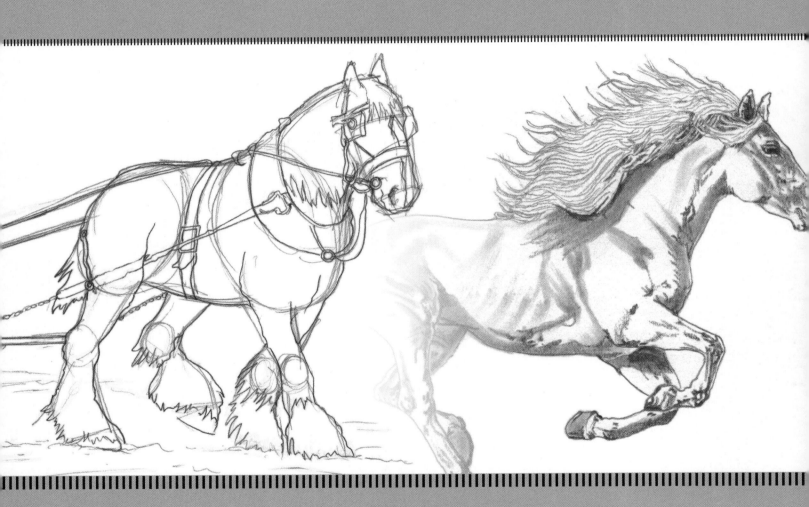

Movement

|||

While a drawing is obviously a static image, there are various ways of portraying the idea of movement to the viewer so that your horses really come alive and spring into motion. In this chapter we shall look at the four paces of the horse – the walk, the trot, the canter and the gallop – and understand how these gaits can be broken down into sequences of foot falls, leg flexes and extensions. However, creating the illusion of movement in a drawing is not simply about the accuracy of your rendering of the subject; it will be helped by the context within which you place your horse and how this background reflects the speed or excitement of the animal you are trying to portray.

THE ILLUSION OF MOVEMENT

While the horse has a standardized sequence of movements within each pace, there is a huge variety of poses and body conformations. When you are trying to understand the visual impact of a moving horse you'll find it really helpful to watch them in a field or riding school, or, just as effective, in videos posted on the internet.

Familiarizing yourself with how the components of the horse's body change within a period of movement will allow you to establish the key features that convey a snapshot of that movement. For example, the horse in Fig. 1 is depicted in mid-leap, the notion of forward momentum conveyed by the streaming mane and tail. The outstretched legs, extended neck and head and long body accentuate the length of the horse. These elements establish a horizontal line within the image that draws the eye forward, following the direction in which the horse is moving.

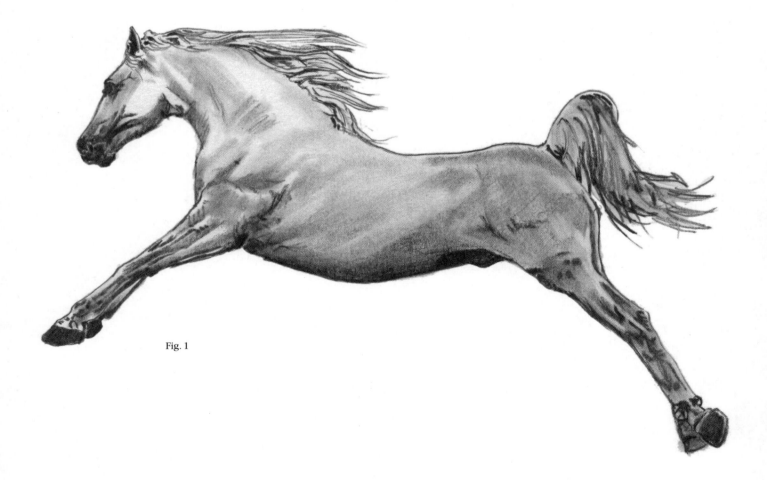

Fig. 1

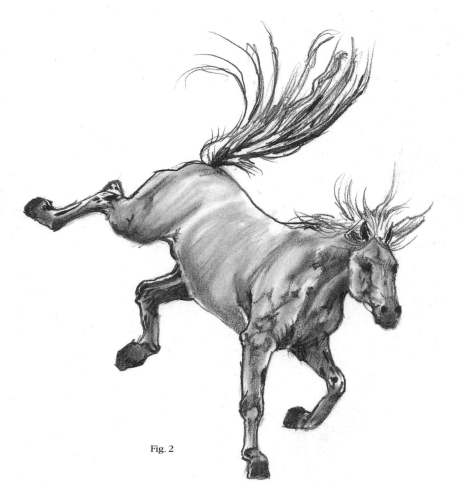

Fig. 2

The studies in Figs 2 and 3 were made after watching some footage of a group of Arab horses frolicking in a field. The flowing manes and tails follow the direction of movement and accentuate the liveliness of the animals, while the flexed and extended legs encourage the viewer to imagine the next stage of movement that will follow.

I believe that depicting movement effectively depends upon creating an image that engages the viewer both visually and emotionally. If you make the picture dynamic and focus on the elements that embody the movement of the horse, you will connect with the imagination and sow the seed of a moving image within the mind of the viewer.

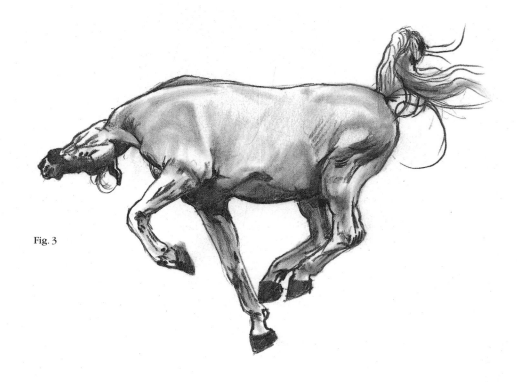

Fig. 3

THE WALK

The walk is a slow four-beat gait. The footfall sequence is illustrated at the bottom of the page. The hooves are lifted off the ground one at a time, and there will always be at least two hooves on the ground in this sequence of movement.

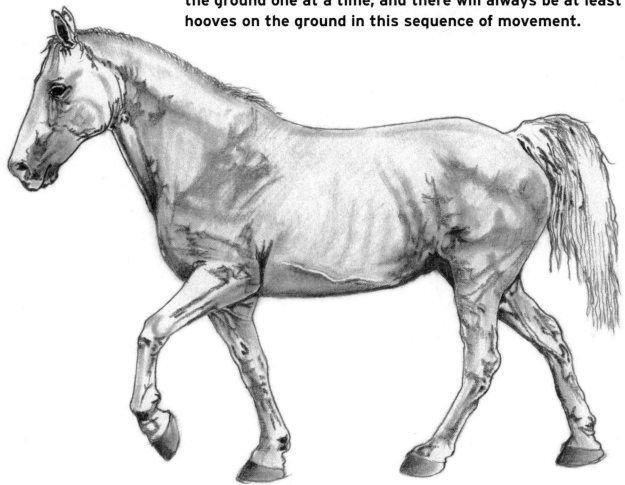

This drawing shows the horse in the process of walking. The left front leg is lifted while the other three hooves remain on the ground. Use the sequence diagram below to help you visualize the next step this horse will take.

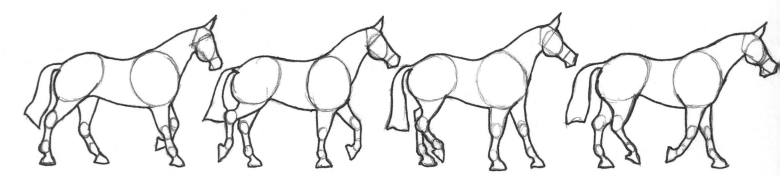

Adding a background to the picture helps to contextualize the
animal. The depiction of the setting reflects the slow motion of the
horse. The detail of the grasses that border the field can be clearly
seen and the soft shadow beneath the grounded hooves establishes
the firm, steady contact between the horse and the grassy meadow.
Creating a softly shaded suggestion of a forest in the distance with
wispy clouds in the sky creates a calm, peaceful atmosphere which
reflects the horse's leisurely progress.

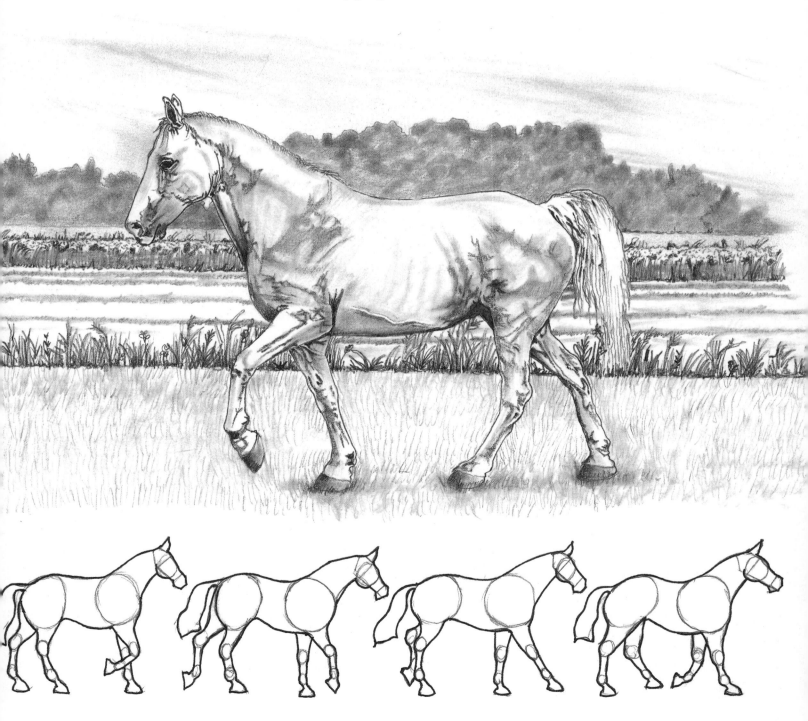

CARTHORSE

A plodding, purposeful carthorse embodies the essence of the slow walking gait. The strength and capability of this breed of horse are evoked by the hairy fetlocks, heavy hooves and thickset proportions. The lines of the ropes and chains harnessing the animal to an old-fashioned plough conjure up the feeling of exertion as the horse steadily pulls against the resistance of the plough blades in the soil.

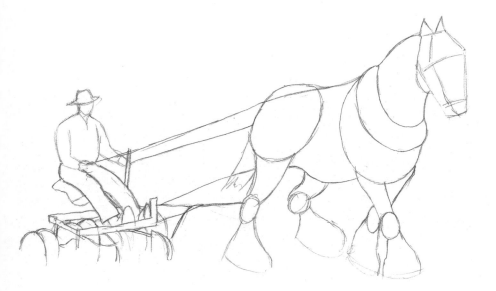

STEP 1

I started by laying out the form of the horse with my HB propelling pencil, using the simple shapes method we looked at in Chapter 1. I used the line of the ropes to establish where to sketch in the farmer sitting on his plough. After roughly establishing the proportion of the man according to the size of the horse, I plotted the general shape of the plough.

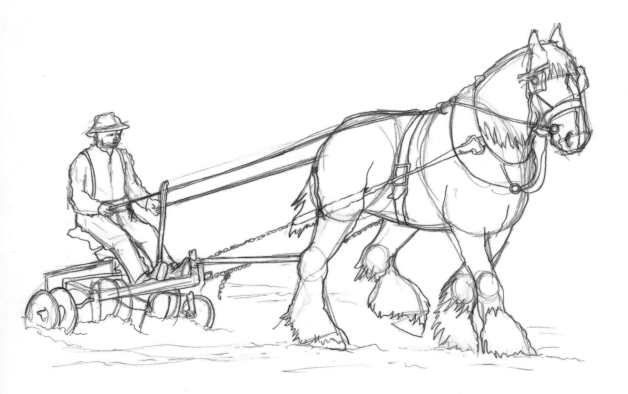

STEP 2

Next I began to refine the outlines of the horse and the man, adding facial detail and lines to explain the harness and chain attachments.

STEP 3

I established the three-dimensionality of the images by shading in the darkest areas of the horse with a regular 2B pencil. I added lines to suggest hair texture in the mane, tail and lower legs and the texture of the ground, paying close attention to the interaction between the plough and the upturned soil. This stage really establishes the composition in its setting and makes sense of the physical process of the horse pulling the plough through the field.

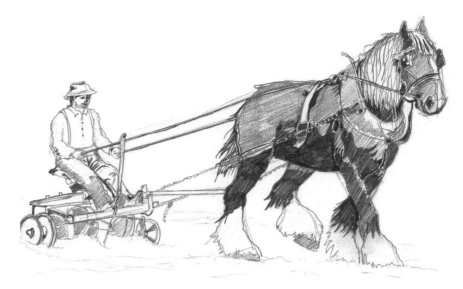

STEP 4

In this final stage, I began to blend and soften the shading with the tortillón. The horse's coat is quite dark, but by blending the shading over the body I managed to retain subtle graduation of dark and lighter areas. This helps to suggest muscle definition and the three-dimensional form of the body. Finally, I added small details such as the stripes and buttons of the man's shirt, the creases of the trousers and the links of the chain attaching the harness to the plough.

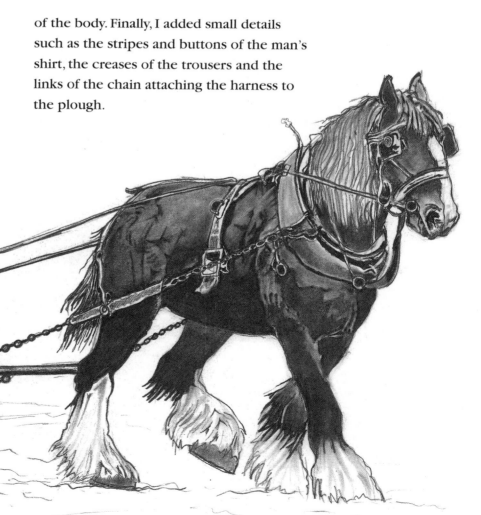

THE TROT

Once the horse begins to speed up, it progresses into the two-beat gait we call the trot. The trot is the horse's equivalent of a jog. The sequence drawing shows how the trot progresses, with the horse raising opposite front and hind hooves above the ground and allowing them to fall together at the end of the stride. Following this the horse will then raise the other diagonal pair of legs.

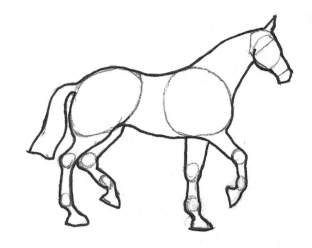

The drawing clearly shows the diagonal pair leg movement. The high carriage of the tail emphasizes the bouncing motion of the trot.

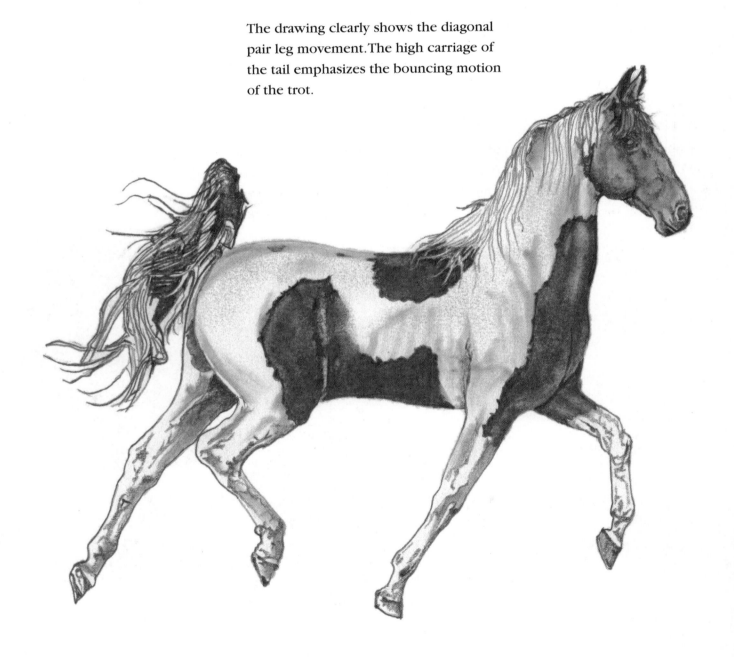

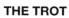

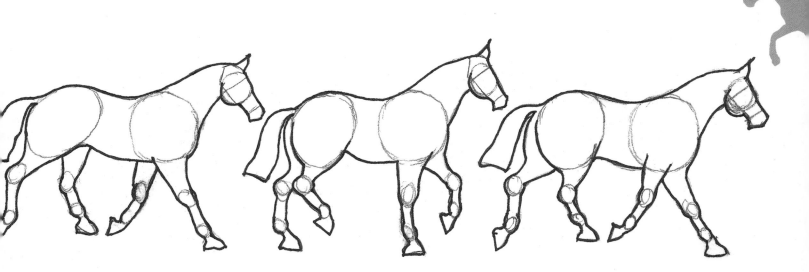

The fenced background creates the perfect context for the trot. The dust disturbed by the hooves on the ground evokes the idea of movement so that the viewer anticipates the horse's next step.

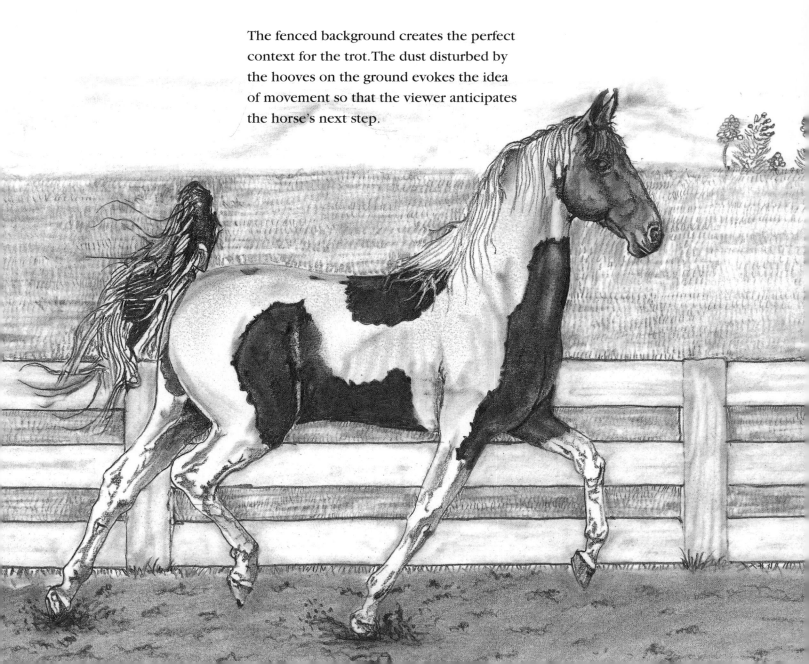

THE CANTER

The canter is the horse equivalent of a steady run. The pace is a little faster than the trot and has three beats. The drawing shows the sequence of this gait. When you are near cantering horses it is possible to hear the three-beat drum of the horses' hooves upon the ground.

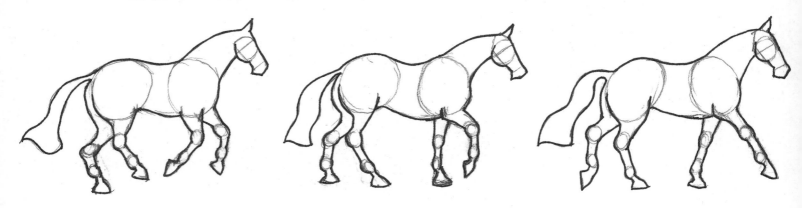

The canter has a brief period of suspension where all four feet are off the ground. You can clearly see this suspension in the drawing. The flowing mane and tail emphasize the increased speed of this gait.

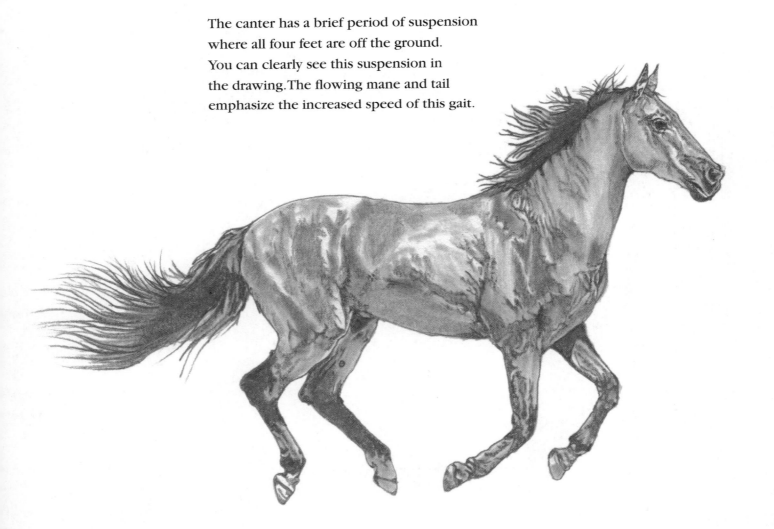

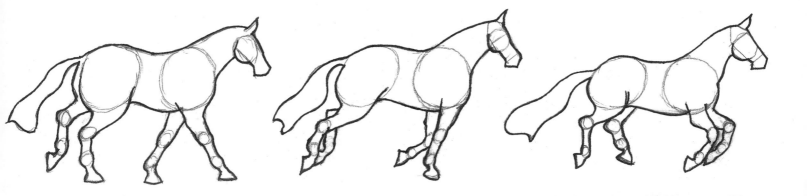

Horses love the feeling of sand beneath their hooves, so the beach is one of their favourite locations to have a run. The horizontal lines of the background help to establish the fast forward motion of the horse, while the shadows beneath the hooves create an interaction between the horse and its surroundings.

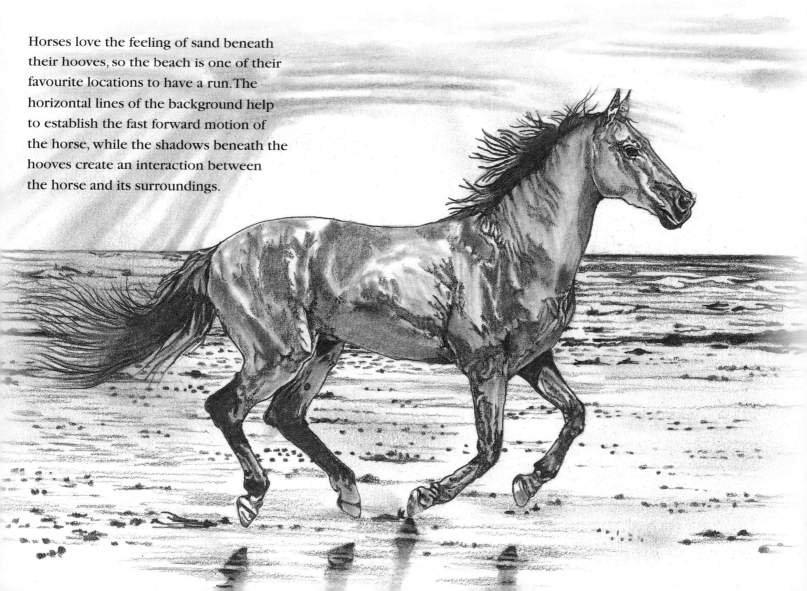

THE GALLOP

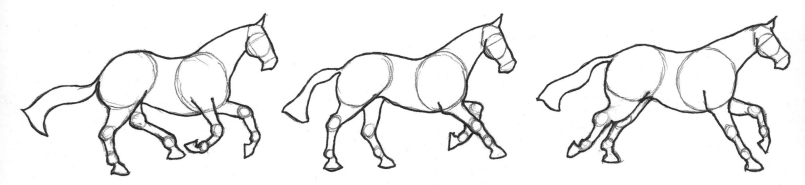

The gallop is the fastest gait. It has four beats and, as in the canter, there is a period of suspension. If you look at the drawing you can see that the gait runs through a sequence of one hoof hitting the ground, followed by the other hind hoof, the diagonal front hoof and lastly the other front hoof. This is followed by the period of suspension. In 1878, the photographer Eadweard Muybridge discovered the exact sequence of leg movement involved in the gallop by making a series of photographs achieved by a galloping horse tripping the shutters of a number of cameras.

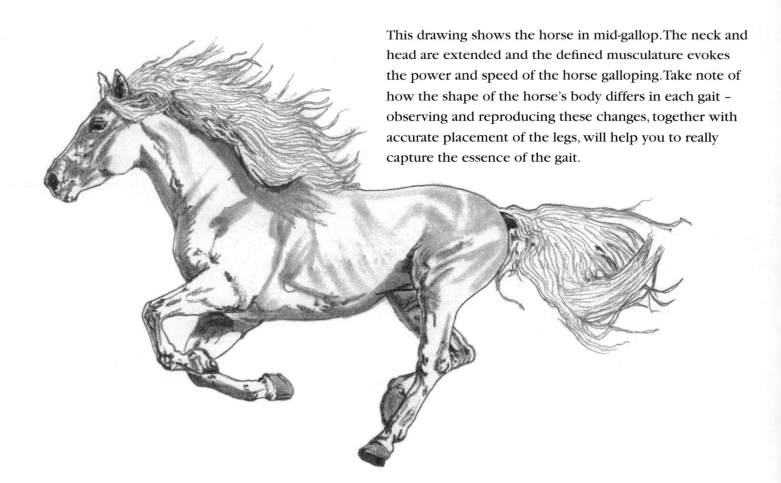

This drawing shows the horse in mid-gallop. The neck and head are extended and the defined musculature evokes the power and speed of the horse galloping. Take note of how the shape of the horse's body differs in each gait – observing and reproducing these changes, together with accurate placement of the legs, will help you to really capture the essence of the gait.

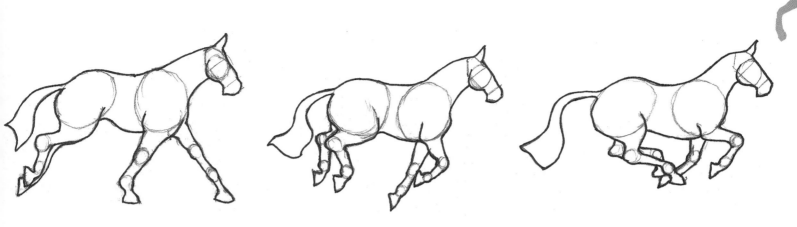

The blurred racecourse background further adds to the illusion of speed. The strong horizontals draw the eye forward in the direction of the horse's movement.

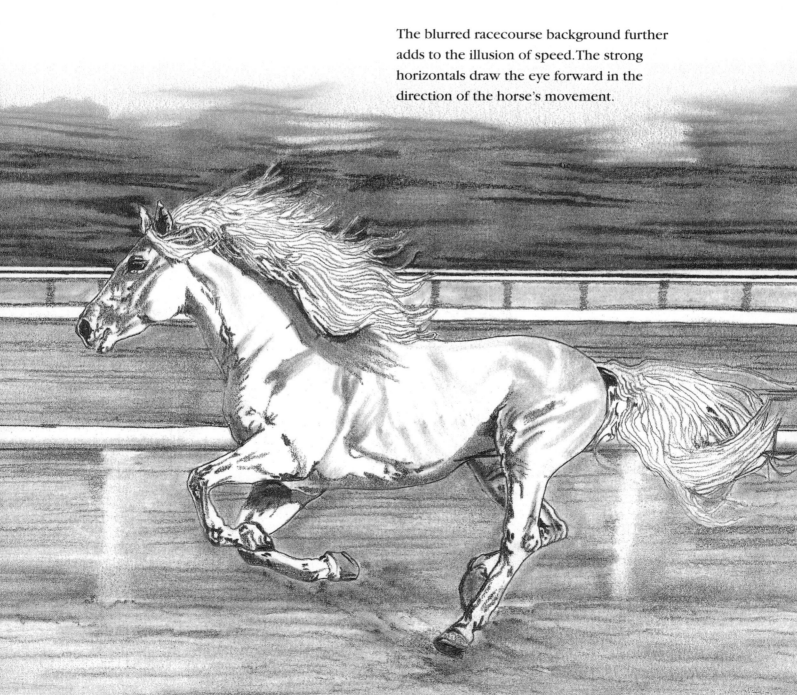

RACEHORSES

Thoroughbred racehorses are well known for their speed, agility and feisty spirit, making them a perfect horse to draw in order to convey the beauty and power of the gallop. The composition here emphasizes the fast forward movement of the race, with the jockeys perched lightly on the saddles and leaning forward into the speed of the horse.

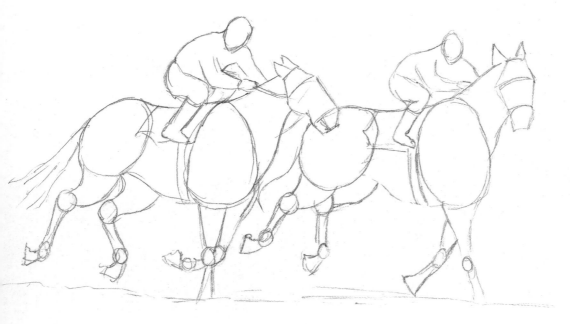

STEP 1

I started by roughly laying out the composition and proportions of the horses and their riders with an HB 0.5mm propelling pencil. Placing one horse in front of the other really adds to the feeling of jostling for position and the competitive speed of the race.

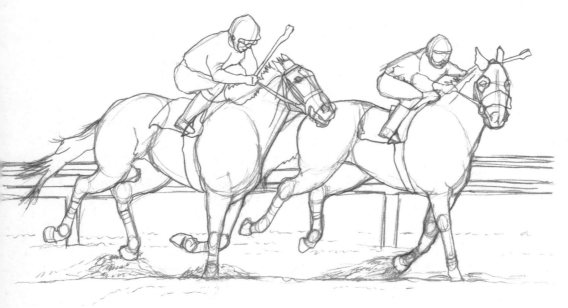

STEP 2

After refining the rough outline and erasing the construction lines, I added facial details to the horses and riders. Putting in the horizontal line of the racecourse barrier begins to establish the feeling of speed and forward motion.

STEP 3

Next I laid out the shading in
the darkest areas of the horses'
bodies using a 2B pencil. One
of the horses is chestnut and
the other a bay, so I made sure I
shaded lightly on the chestnut
horse and more heavily on
the bay to maintain a contrast
between the two horses. To
darken the bay horse even
further I used a softer 4B
pencil.

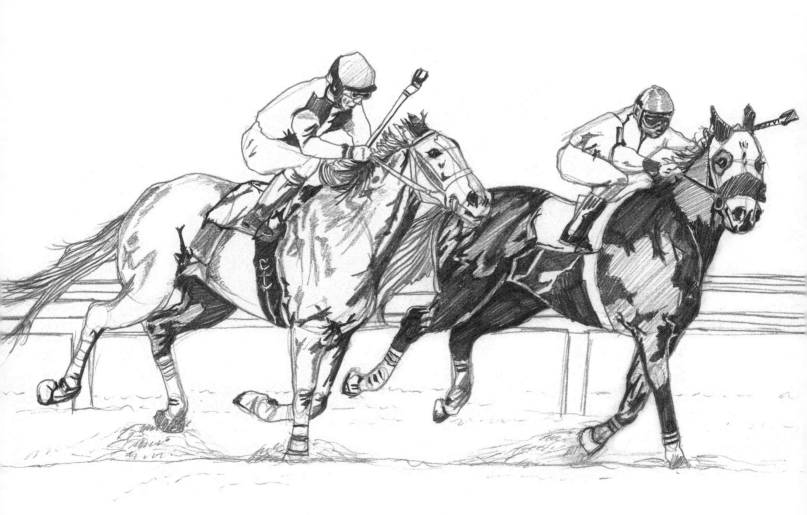

STEP 4

To finish the drawing I
blended all the shading to
produce a smooth, glossy
coat on both horses. I wanted
the composition to convey
speed, energy, power and the
urgency of the jockeys, a feeling
evoked by the disturbed dust
at the horses' hooves and their
streaming manes and tails.

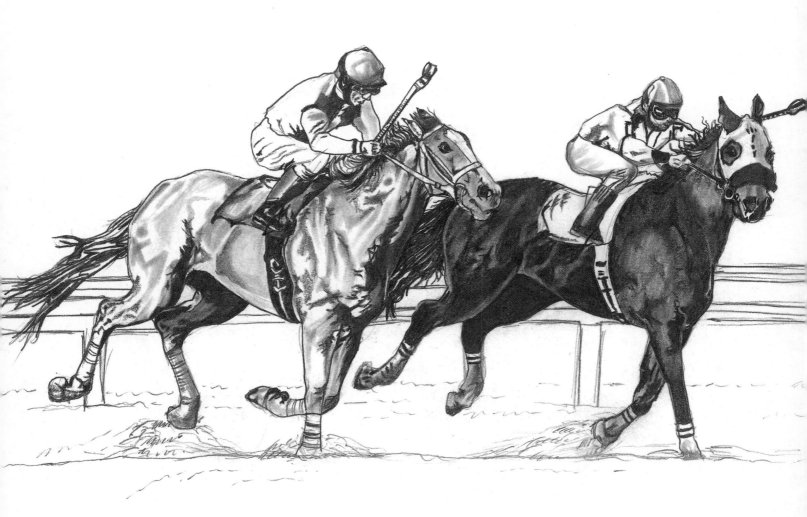

THE JUMP

The act of jumping comes naturally to the horse. Understanding the sequence of movement will expand your visual image bank, enabling you to add variety to your drawings portraying a horse in motion.

Show jumping is a skilful and graceful equestrian sport which takes a lot of interaction between the horse and the rider. The rider's experience and understanding of the horse ensures that both of them take the jump safely.

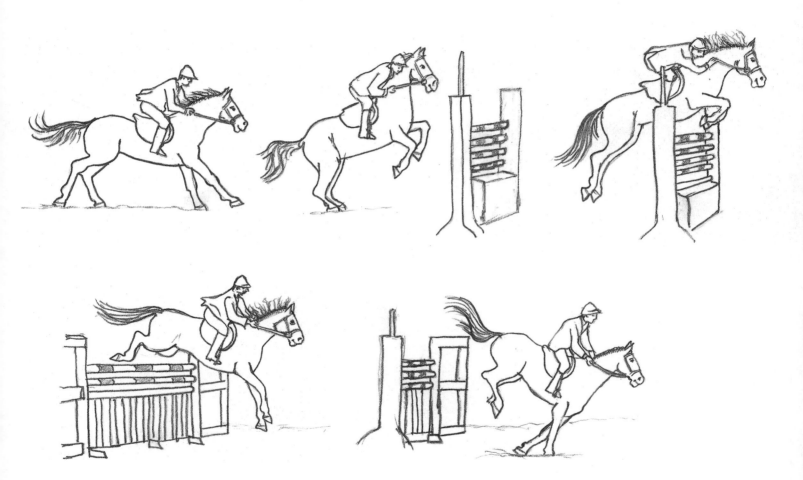

These studies show the movements involved when a horse takes a jump. There are five main elements to this process: the approach, the take off, the airborne suspension over the jump, the landing and the recovery of the horse leaving the jump.

THE HUNTER

As you might expect, the hunter is a sure-footed sturdy horse, with the muscular power to jump and land upon uneven ground and the calmness of demeanour to be around hounds. In this composition I wanted to show the close interaction between the horse and rider when a jump is taken as well as the poise and elegance of the jumping horse.

STEP 1

Establishing the proportions of horse and rider using simple shapes was again the best way to start off. Using my propelling pencil, I made sure the size relationship between the two created a harmonious union. I established roughly where the jump would appear beneath the front legs and added lines to show where foliage is present in front of the back legs and around the base of the jump.

STEP 2

After refining the lines I added detail to the mane and tail, the horse's face and the dress of the rider. I took the time to describe the saddle and stirrups – this part is very important since it is the thing that unites the horse with the rider. The same is true of the bridle and reins.

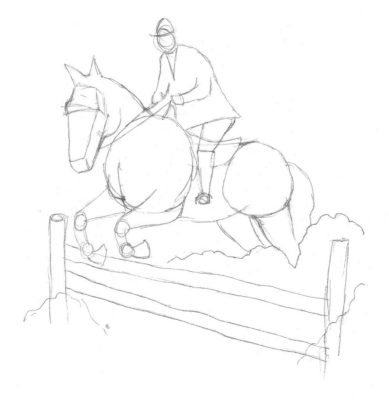

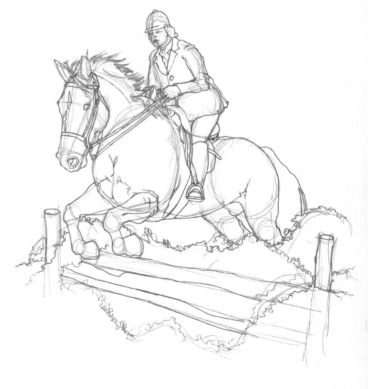

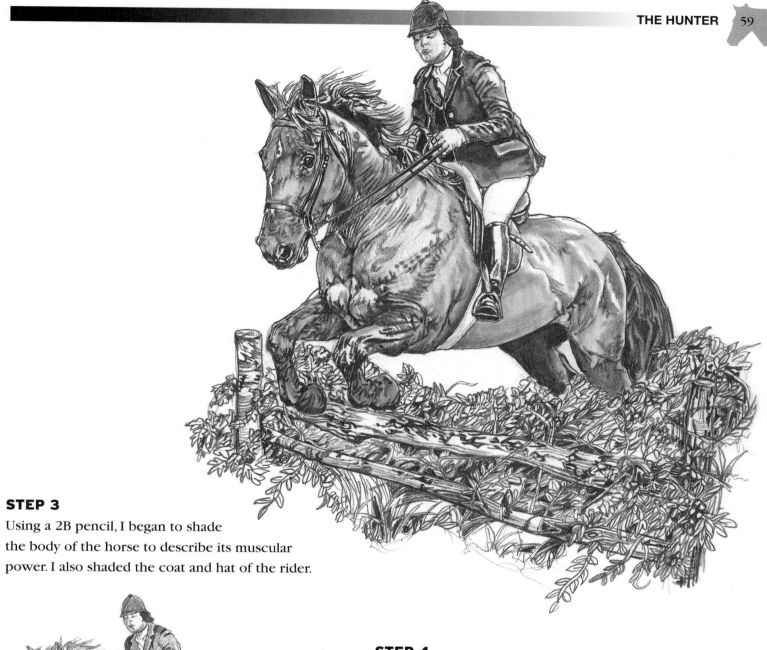

STEP 3

Using a 2B pencil, I began to shade
the body of the horse to describe its muscular
power. I also shaded the coat and hat of the rider.

STEP 4

Blending the shading gave the horse a smooth power
and elegance. The next job was to describe the foliage.
While this took some time and looks quite complicated,
it is in fact relatively simple to achieve; by drawing
small random leaf shapes over and over again you begin
to build a dense covering that emulates the tangled
foliage and stems that grow around fences. I returned
to my propelling pencil for this part of the drawing
because it allowed me to achieve a constant fine line
when making the small leaf and stem shapes. The fence
is constructed of a few roughly hewn logs. Adding
texture to the surface of the wood, using the softer 2B
pencil, evokes the natural rustic quality of the fence.

THE LIPIZZANER

I wanted to create a composition with the Lipizzaner since it is a horse with such a unique and astounding repertoire of movement. The most famous Lipizzaners are those of the Spanish Riding School in Vienna, where moves such as the capriole (shown below) are perfomed as part of breath-taking displays of classical horsemanship.

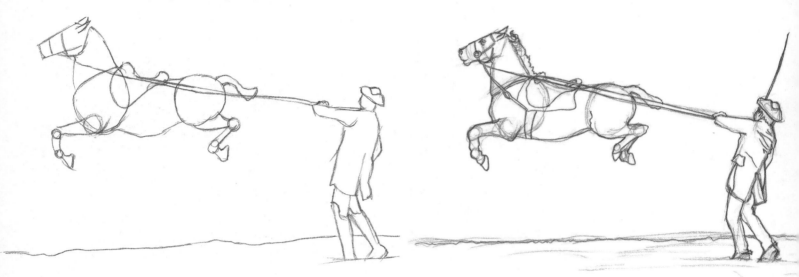

STEP 1

I laid out the composition using my HB propelling pencil. My main concern was to emphasize the impressive height that the horse can jump, so I drew the man handling the horse proportionally slightly smaller than normal. I made sure the horse's legs flexed high into the body, creating a strong horizontal line, then roughly laid out the position of the ropes which unify the relationship between the horse and the handler. This establishes the control and involvement needed to make the horse achieve this jump.

STEP 2

After refining the outline I added lines to suggest the location of the mane, bridle and saddle girth and began to add detail to the horse's face, carefully positioning the eye and nostril. I then added lines to suggest the folds in the fabric of the handler's coat.

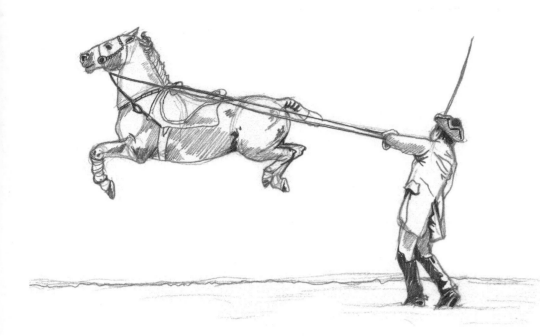

STEP 3

Next, I softly shaded the horse and handler using a 2B pencil to establish the three-dimensional substance of the composition. I used a softer 4B pencil to establish the darkest tone of the handler's boots.

STEP 4

Finally, I blended the existing shading and softly shaded the grass, darkening the area beneath the handler's feet; this grounds him in the composition and also emphasizes the height of the jumping horse.

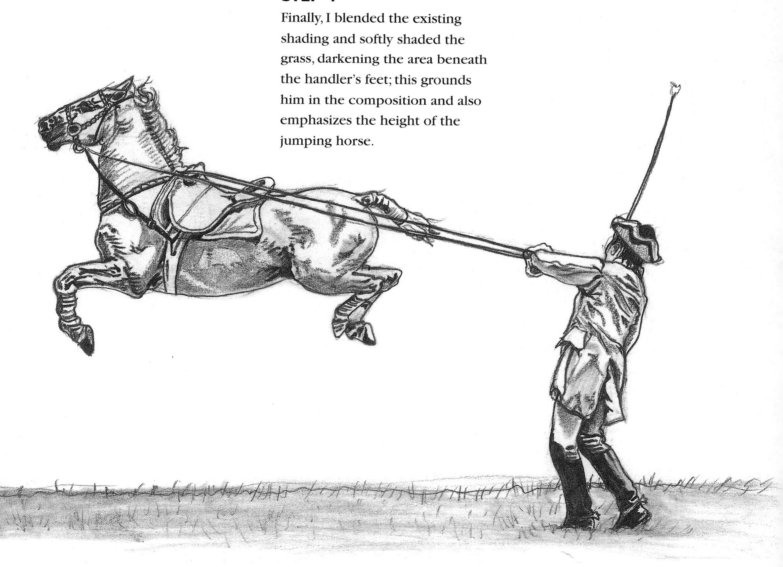

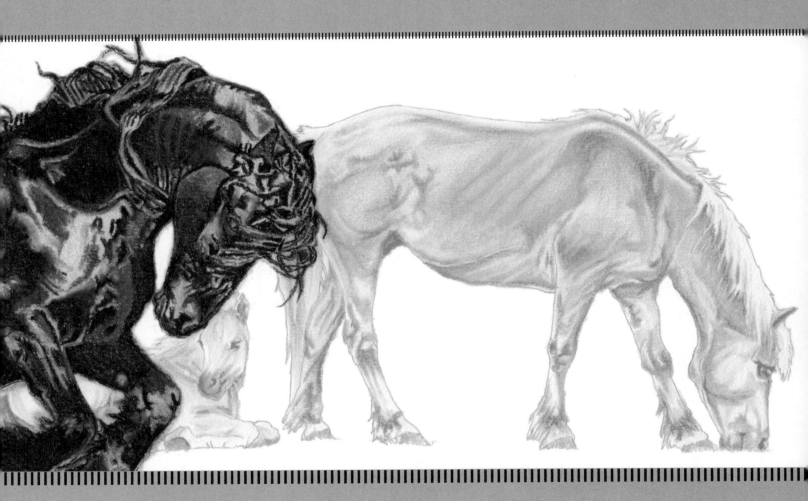

Breeds and Techniques

The horse has been domesticated and bred by humans to produce animals best suited to a particular job – strong, heavy horses to pull a plough, quick, nimble horses with stamina that can run for long distances or small, sure-footed ponies that can travel easily on uneven ground, for instance. This engineered breeding has resulted in a wide variety of shapes and sizes of horse. In this section we shall look at some of the varieties of horse and pony around the world and the distinctive features that characterize the breed.

THE ARAB

One of the most ancient and beautiful horses in the world, the Arab is easily recognized by the 'dished' face, broad forehead, wide nostrils, large eyes and high, plumed tail. The ancestors of the modern Arab were bred by Bedouin tribes and the horse we know today still retains the stamina and physical strength that evolved to withstand the harsh desert conditions.

In my study I have tried to capture the distinctive physical beauty of the Arab and evoke its muscular energy, strength and intelligence. Before starting work, I made a list of the key features to accentuate in my drawing so that my mind was focused on conveying the essence of the breed; small head and ears, large eyes and nostrils, dished (concave) profile, high tail and a defined musculature of rump and powerful neck.

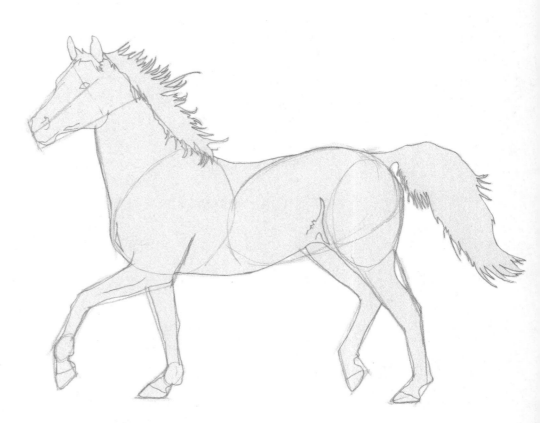

STEP 1

Using my HB 0.5mm propelling pencil, I lightly sketched the outline of the horse, using simple, angular shapes to help me establish a good proportional relationship between the head and the neck. I worked out that the length of the neck was roughly half the total length of the body and so used this ratio when planning the circles that describe the horse from the chest to the rump. I used a similar ratio relationship to plan the length of the legs. By using this method I could be fairly sure of the proportional correctness of my outline. I refined this simple framework and added the outline of the mane and tail. I was then able to erase my preliminary working.

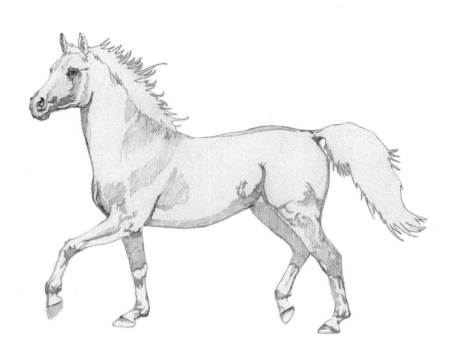

STEP 2

Using an HB light wash watersoluble pencil, I began to lightly shade the darker areas of the horse. This working begins to suggest the three-dimensional form and musculature of the body. I think the most defining and engaging feature of any animal is the eyes, so I took time to portray the reflectivity of the Arab's large eye, focusing on the impact created by the contrast between the bright white highlight at the corner and the deep shade of the iris.

STEP 3

I started to blend my pencil shading with a moistened No. 1 round watercolour brush. This method helped to suggest broad areas of light shadow as well as the muscle structure beneath the skin. With an 8B watersoluble pencil I began to darken the areas around the neck, chest, belly and far legs of the horse, as well as the nostril, ear recess and hooves.

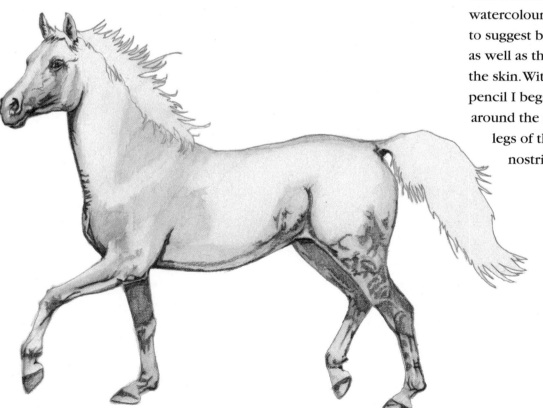

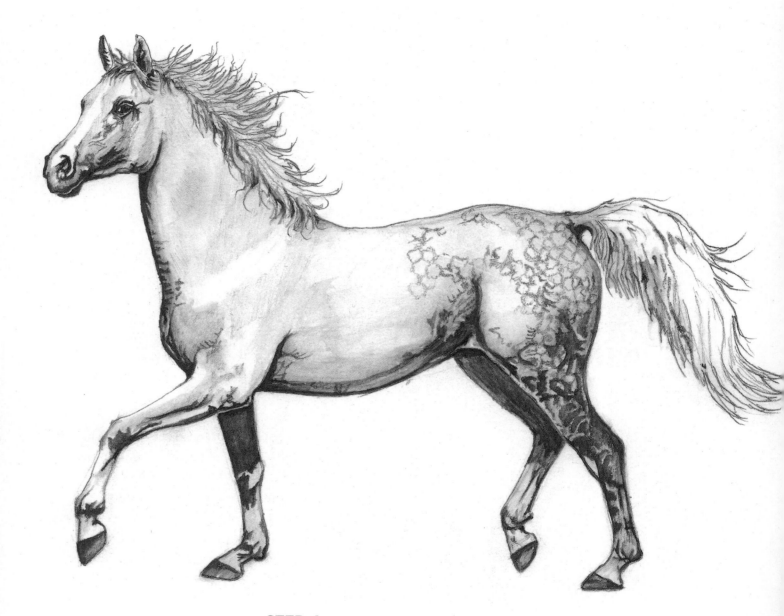

STEP 4

For this final stage I blended the dark 8B pencil into the lighter shadows with the wetted watercolour brush. This gives a subtle graduation of shade and light. The horse has a beautiful dappled pattern on its rump and I used a soft shading technique to describe these markings. I then blended them in with the darker tones of the near hind leg. Finally I added lines and shadow to the mane and tail to describe the flowing movement of the strands of hair. This final detailed working really brings the horse alive and makes the observer aware of the life and energy of its character.

WATERSOLUBLE PENCIL TECHNIQUE

Derwent watersoluble pencils are perfect for creating smooth graduations of light and shade. Like normal pencils, they are graded according to the density of the lead and they are available with very soft leads to achieve dense dark washes and harder leads for light translucent washes. Simply shade the area with the light or dark pencil and use a wet brush to blend the pencil and graduate the shade. They are very easy to use and are a good place to start practising and perfecting your painting skills. When starting a drawing, it is always a good idea to work from light to dark gradually – you can always add to the shadow but dark areas laid in early are difficult to erase if you realize they don't look right.

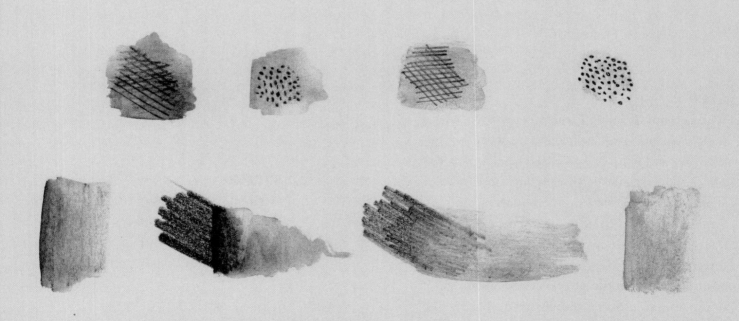

THE SHETLAND PONY

This breed of pony originates from the Shetland Islands, located about 160km (100 miles) north of Scotland. They are hardy little animals with a thick coat to protect them from the harsh weather and short legs and body, making them good at walking on uneven ground. They are very strong and were used during the Industrial Revolution as pit ponies, hauling coal to the surface of the mines.

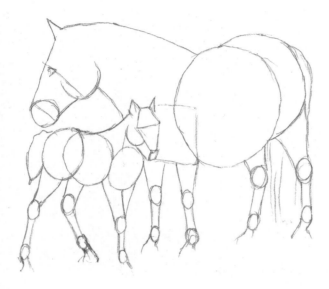

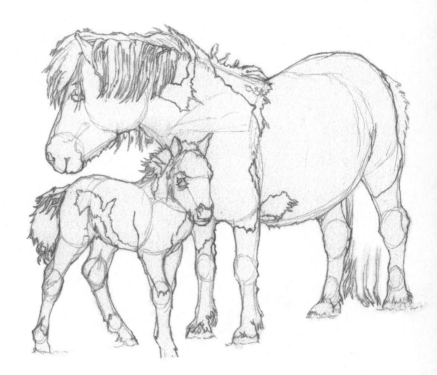

STEP 1

With this composition I wanted to show the close emotional connection between the mare and her foal as well as their physical form. I started by drawing the simple shapes to make up the bodies of the ponies, using my HB propelling pencil. As the mare is seen at an angle there is some foreshortening in her body and I needed to concentrate on the direction and angles of the lines to create a visually believable image. I also paid close attention to the physical differences between the foal and the adult, accentuating the foal's long legs, short fuzzy tail and small body.

STEP 2

I refined the outlines of the pair and added the distinctive thick shaggy mane to the line of the neck. At this stage of life, the foal has only a short, sticking-up mane.

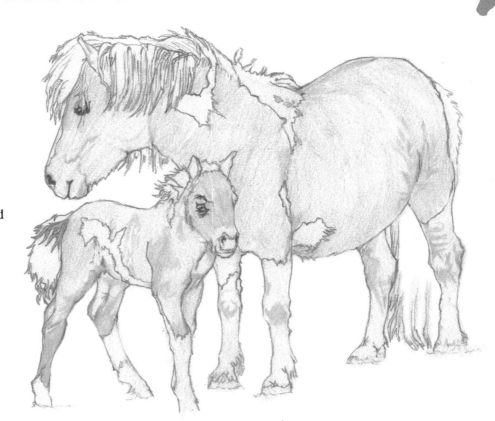

STEP 3
With a light grey pencil, I lightly shaded all the coloured parts of the ponies' coats, leaving the white patches untouched I used a black pencil to colour in the eyes and nostrils.

STEP 4
With the black pencil, I began to build up the texture of the pony's coat, varying my pressure and pencil stroke direction to evoke the barrel form of the belly and ribcage.

STEP 5

After applying the same technique to the coat of the foal, I used both the grey and the black pencil to lay in the ground and texture of the grass. Finally, to soften the texture a little, I used the tortillon to blend the pencil marks.

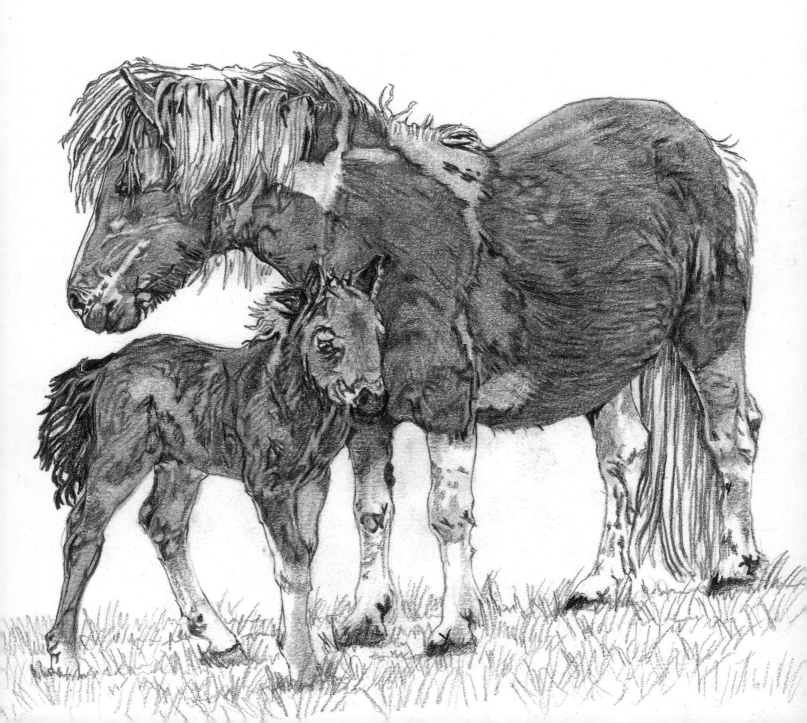

COLOURED PENCIL TECHNIQUE

Caran d'Ache coloured pencils are watersoluble and can be used dry or blended with a wet brush after they have been applied to the paper to create beautiful, intricately finished drawings. Like watercolours, they are lightweight and easy to transport, so they are perfect for use in outdoor sketches. Their soft leads mean they can be blended easily and they also have an intense pigment quality and dense coverage. While this blending is subtle and immediate I wanted to use the pencils dry to evoke the rough texture of the Shetland's coat, so in my drawing I did not use any water blending. Instead, I used short strokes of the pencil to establish the roughness of the pony's coat.

THE APPALOOSA

This horse is best known for its beautiful spotted coat, the pattern of which varies greatly, making the breed visually diverse. The 'spotted blanket' Appaloosa has a white rump, clearly showing large and small spots, while the rest of the horse may be bay, brown, chestnut, roan or black; the 'leopard' has a white base coat which is entirely covered with spots, while the 'snowflake' has a dark base coat with white spots and flecks and the 'marble' is mottled all over the body. The mane and tail are usually very sparse, thin and wispy. The breed has a distinctive eye, with white in the area around the cornea, known as the sclera. Originating in the USA, the Appaloosa is today one the most popular horses in that country.

The main feature of the Appaloosa that I wanted to highlight in my drawing was of course its unique spotted coat. I thought the stark contrast of black ink on white paper would be really effective for this exercise.

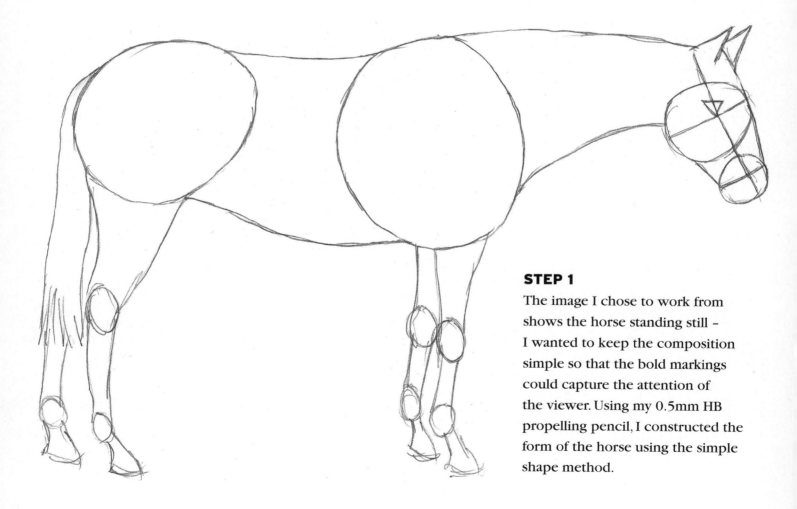

STEP 1

The image I chose to work from shows the horse standing still – I wanted to keep the composition simple so that the bold markings could capture the attention of the viewer. Using my 0.5mm HB propelling pencil, I constructed the form of the horse using the simple shape method.

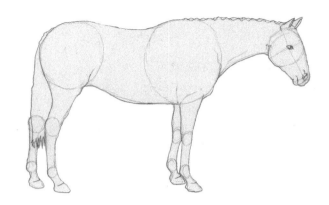

STEP 2

Next, I lightly erased the construction lines and refined the outline to give a more realistic shape.

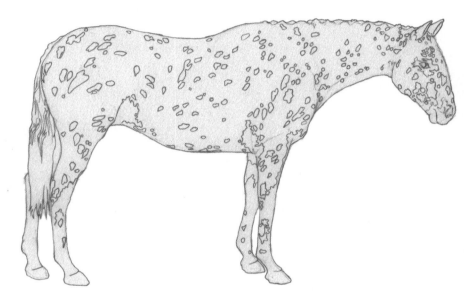

STEP 3

I chose to draw a leopard Appaloosa, with its white base colour entirely covered with spots. With the HB propelling pencil, I began to draw outlines of spots on the body, making sure that the shapes were quite random so as not to create too uniform a pattern. Looking at the reference image, I followed the pattern closely to achieve a realistic coat marking. At this stage, any markings that I wasn't happy with were easily erased.

STEP 4

Once my spot pattern satisfied me I inked in the marks, using a brush pen which allowed me to follow the outlines of the spots closely but also fill in the shape smoothly. I used clusters of dots to describe slightly shaded areas. When that was done I added detail to the eye with a fine-nibbed ink pen.

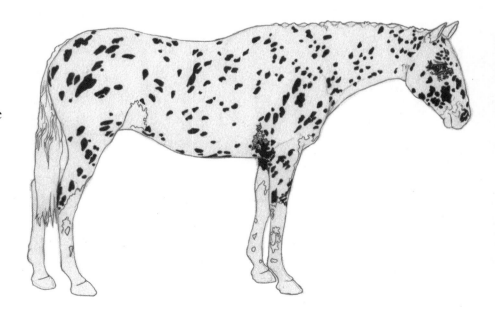

STEP 5

Next I inked in the horse's black socks and then, using the fine-nibbed pen, drew in the lines to describe the hairs of the tail. This horse has a plaited mane, so I used the pointillist shading technique (see p.11) to explain the knots of the plaits along the ridge of the neck. I added more pointillist shading in other areas. This really added to the three-dimensional form of the horse and gave the drawing substance.

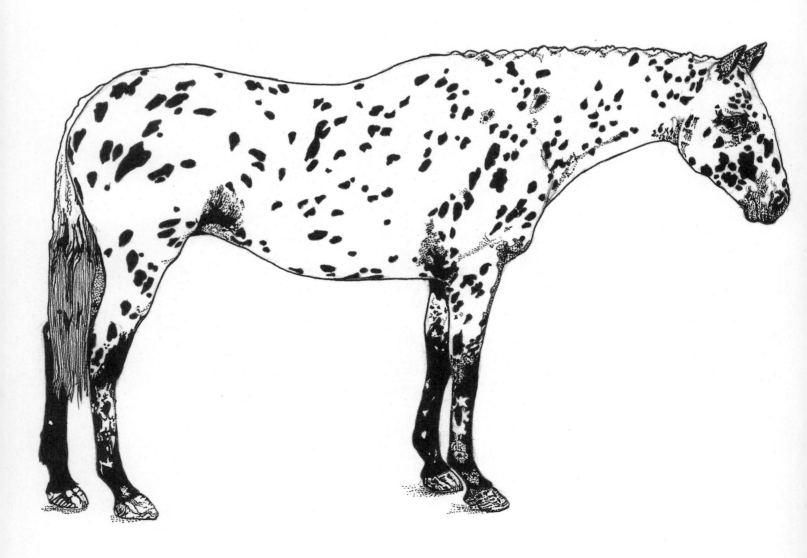

PEN AND INK TECHNIQUE

Since pens come in a variety of sizes, pen and ink is a very versatile technique with many different qualities and thicknesses of line available. A fine-nib pen such as the Staedtler 0.3mm pigment liner can create precise, controlled details of delicate contour or hatched shading. Graduated shading can also be achieved using a pointillist technique (see p. 11).

Thicker-tipped ink pens are excellent for drawing a bold, dark outline around an image to make it stand out from the background, while brush-tipped felt pens make beautiful fluid lines which can be varied in thickness by either using the fine-tipped point of the brush or angling the brush against the paper to produce a thicker line. These brush pens are also watersoluble and can be blended like watercolour by using a wet brush.

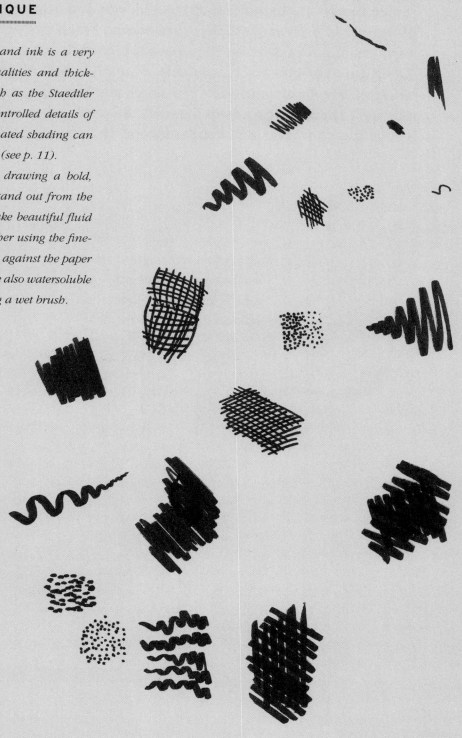

THE HAFLINGER PONY

This pony takes its name from the village of Hafling (now Avelengo in the Alto Adige region of northern Italy), which was the principal breeding centre. The Haflinger is a strong, stocky, sure-footed breed perfect for working with the farmers and foresters on the uneven, mountainous Austrian ground. It has a beautiful liver-chestnut body colour which is set off by a thick flaxen mane and tail. The limbs and neck are short and strong and the head is small yet sturdy. I thought the easily blended tones of soft pastel would be perfect to evoke the character and appearance of the sturdy Haflinger.

STEP 1

I thought this composition of the mother grazing with her sleepy foal was really charming. I started by sketching the simple forms of the horse and foal using the HB propelling pencil, making sure they had a correct proportional relationship.

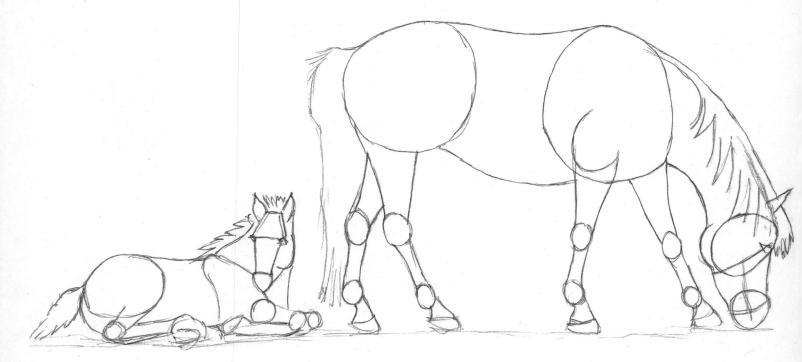

STEP 2

I refined the outline of the mother and foal and then began to erase my preliminary working so that I could concentrate on developing the realism of the two animals. I added a small star shape to the forehead of the foal and added detail to the eyes and nostrils of both animals.

STEP 3

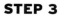

Using a light grey mid-tone, I blocked in the areas of shade, making sure I left white paper showing clearly to maintain the highlights of the picture. With a black pastel, I added detail to the eyes so that the picture began to come alive. Starting this facial detail early on in the process allowed me to visualize the finished picture and helped me to plan how dark I needed to make the deepest shadow.

STEP 4

Using the black pastel, I carefully deepened the shadows and blended them with the tortillon. I kept the shading of the foal much softer to help to maintain a distinction of age between the mother and her baby.

STEP 5

By rubbing the grey pastel horizontally against the paper I produced a scumbled effect to represent the grass upon which the horse and foal stand. I blended this with the tortillon to soften the focus of the background and draw the eye to the horses. I then added short, vertical strokes over this blended ground to evoke the texture of the grass. I felt that I had darkened the shoulder of the mare too much, so I lightened and blended this slightly by rubbing the grey pastel over the paper and blending further.

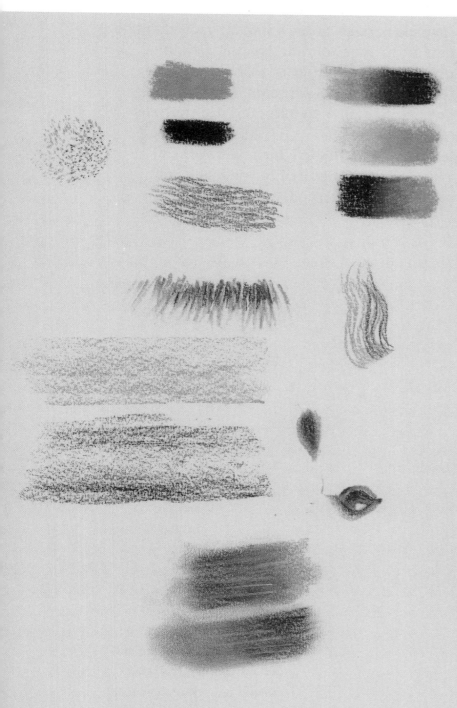

PASTEL TECHNIQUE

Pastels come in a variety of forms, each with their own technical advantages and disadvantages. The two main types are oil and soft pastel. Oil pastels are perfect for large, bold images, but it can be difficult to achieve detail with them when working on smaller pictures. For this reason I have chosen to work with soft pastels on this study. A paper with a 'tooth' is a good surface for making a pastel drawing as the pastel clings to it.

Before you start working on a drawing, experiment on some scrap paper so that you become familiar with the different ways of handling the medium. Here are some different marks made with black, grey and white pastel sticks. You can see that different tones can be easily blended together using a tortillon to produce a soft tonal graduation. When creating a thick layer of pastel by rubbing the stick hard across the paper, make sure you blow or brush away the excess pastel dust which forms on the surface. If left on the paper, this dust could smudge into the rest of your work and ruin the effect of your image.

Graduated tone can also be created by softly rubbing the pastel on the surface of the paper, producing a grainy scumbled effect. Pointillist and cross-hatching techniques (see pp.10–11) are also effective to create less dense tonal graduation.

THE FRIESIAN

The Friesian horse with its glossy black coat, broad head, long, thick mane and tail and feathered feet is one of the most distinctive and strikingly beautiful equine breeds. It originated in the Netherlands, bred for the strength to participate in battle as a war horse. Although Friesians are quite large horses they are also very elegant - a characteristic that has made them very popular as dressage horses.

Charcoal seemed to be the perfect medium to use for my drawing of a Friesian horse, partly because its darkness is suited to the black coat and also because its boldness goes with the strong, noble presence of the horse.

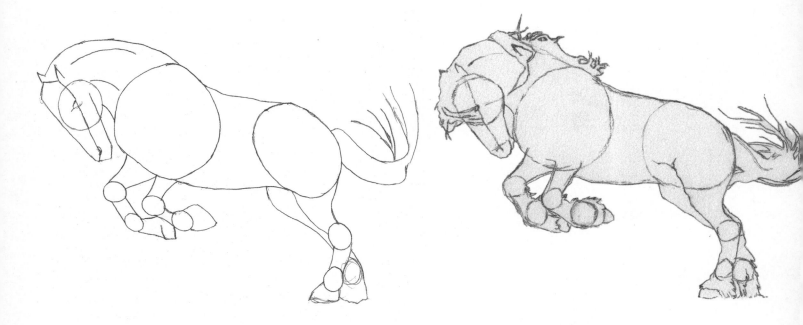

STEP 1

When working with charcoal and chalk it is best to use a paper with a grain, or 'tooth', that gives the charcoal something to bond with, so that is what I did here. First, I laid out the form of the horse using my HB propelling pencil.

STEP 2

Next, I refined the outline and added flowing detail to the mane and tail, which began to establish the drama which I wanted to evoke in the finished image.

STEP 3

I laid in some rough guidelines within the form of the horse to help me establish the juxtaposed areas of dark and light. These lines would also help to show off the muscular tone of the body when the dark tones were added.

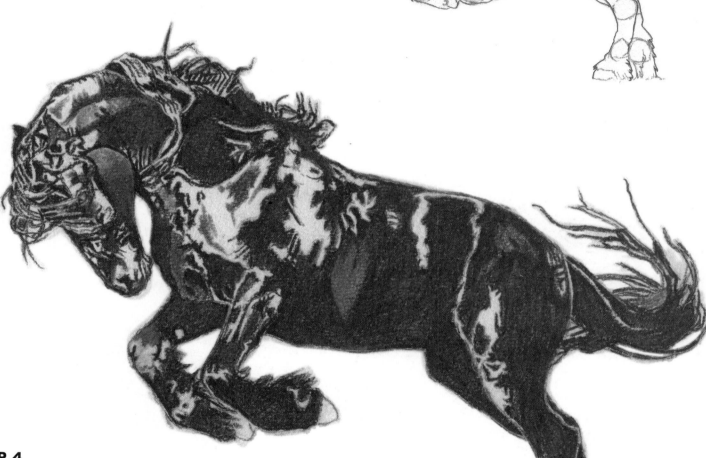

STEP 4

My aim was to make the image bold and strong and create stark contrast between dark and light, following in the chiaroscuro tradition used in late Renaissance paintings. I roughly blocked in the dark black regions with a hard compressed charcoal pencil, leaving the bare white paper to shine through in the reflective areas. This stage begins to describe the sheen of the coat and the horse's muscular body.

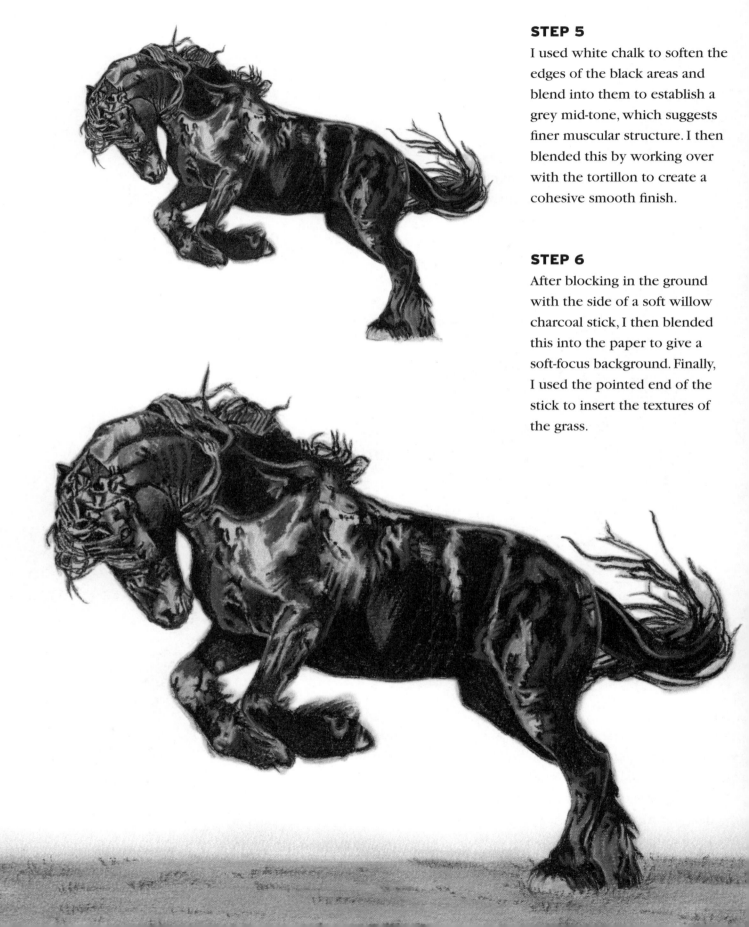

STEP 5
I used white chalk to soften the edges of the black areas and blend into them to establish a grey mid-tone, which suggests finer muscular structure. I then blended this by working over with the tortillon to create a cohesive smooth finish.

STEP 6
After blocking in the ground with the side of a soft willow charcoal stick, I then blended this into the paper to give a soft-focus background. Finally, I used the pointed end of the stick to insert the textures of the grass.

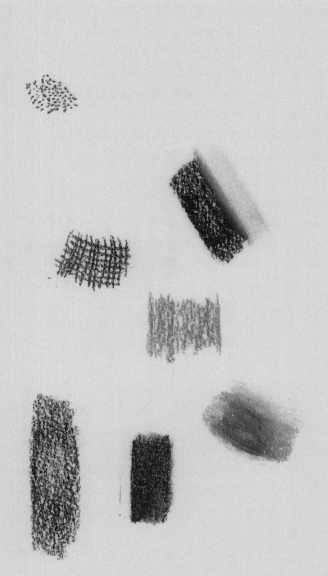

CHARCOAL AND CHALK TECHNIQUE

While charcoal comes in a variety of forms, it is all created by burning wood slowly until all moisture is removed, leaving brittle black sticks. 'Vine charcoal', made by charring thin sticks of willow, is available in a range of consistencies from soft to hard. These willow charcoal sticks are great for drawing quick, sketchy outlines, since the lines can be easily erased as long as they are only laid in softly.

Compressed charcoal is used in charcoal pencils and is made by grinding the charcoal sticks into powder and then rebinding it using a gum binder. The more binder used, the harder and denser the charcoal. This compressed charcoal is good for blocking in really dark areas in a drawing.

White chalk is useful in conjunction with charcoal, both for blending and lightening the black and also for adding pure highlights when you are using paper that is not white.

THE ANDALUSIAN

This Spanish horse has been recognized as a breed since the 15th century. Its strength and stamina made it useful as a war horse, which ensured its survival for hundreds of years. The breed is predominantly white and is known for its distinctive long silky mane. Broad in the hindquarters and chest, with elegant strong limbs, it has a long neck, broad forehead, straight profile and large lustrous eyes, making it one of the most noble and handsome breeds of horse. The horse I have chosen to paint perfectly sums up the characteristics of the breed and the rearing stance adds drama to the image.

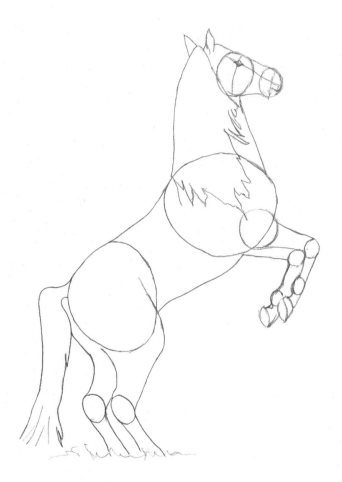

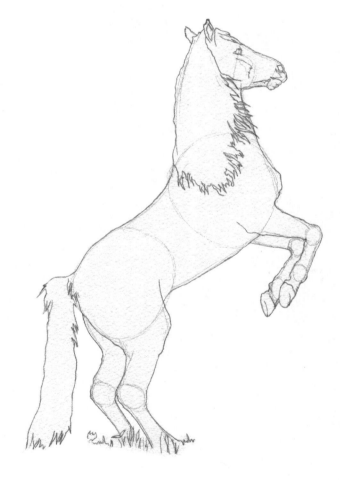

STEP 1

First, I constructed the basic form of the rearing horse made up of simple shapes, using my HB propelling pencil.

STEP 2

Next, I refined the outline and added detail to the head and long, distinctive mane.

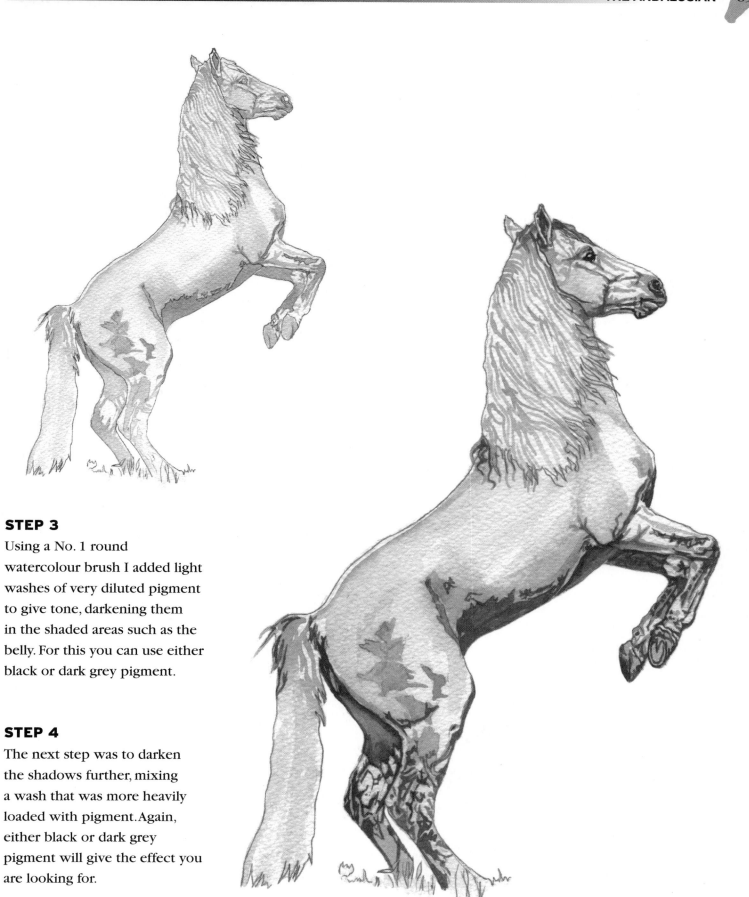

STEP 3

Using a No. 1 round watercolour brush I added light washes of very diluted pigment to give tone, darkening them in the shaded areas such as the belly. For this you can use either black or dark grey pigment.

STEP 4

The next step was to darken the shadows further, mixing a wash that was more heavily loaded with pigment. Again, either black or dark grey pigment will give the effect you are looking for.

STEP 5

Finally, I used a brush loaded with a pigment-heavy solution of black paint to make the dark lines that describe the textures of the mane and tail. Watercolour is beautiful in its immediacy and spontaneity, so try not to overwork the picture; allow the paint to speak for itself. The other quality it is admired for is its luminosity, so use only a few layers so that the light of the paper can still be seen through the translucency of the paint washes.

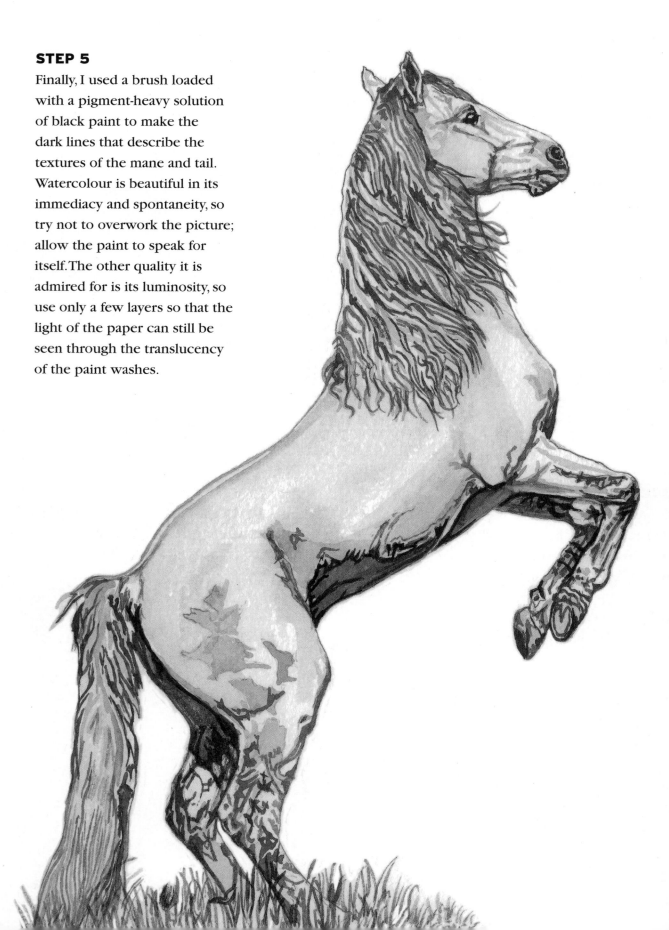

WATERCOLOUR TECHNIQUE

You can achieve a wide variety of marks with watercolour, from intricate details to beautifully translucent, delicate washes. It is one of the most popular paint mediums and is very accessible to the beginner, since the easily transportable box of paints makes it perfect for painting from life on outdoor locations. The paint comes in either small tubes or in solid pans (bricks), the latter probably being best for beginners who are not yet sure which pigments they will use in large quantities.

Light washes can be achieved by mixing very small amounts of pigment in water. Dip your wet brush into the pan and transfer the pigment to your palette, then add plenty of water with the brush to make a very dilute paint solution. For a stronger wash, to make darker, shadowed areas for example, use a greater proportion of pigment to water and add washes gradually so that the tones are built up slowly. A denser pigment solution is also best for creating thin outlines.

When working with watercolour it is important to use paint sparingly, for once an area has been darkened the pure white of the paper cannot be restored. Light areas must be left altogether free of paint, so that highlights are provided by the blank paper.

It is important to use paper designed for watercolour when painting. I use a 300gsm (140lb) Bockingford watercolour paper. Thinner papers tend to cockle (lose their flat surface) or degrade when water is added to the surface.

THE MUSTANG

While it is not large, this horse is hardy and strong. It is probably most familiar to people as the bronco of Western films, ridden by cowboys. Mustangs are known as feral horses, for although they roam free, they cannot be described as truly wild because they are descended from the domesticated animals which were introduced to the Americas by Spanish colonists in the 16th century. The Native Americans soon began to use the horses to hunt and transport goods, and they have become an important symbol of American identity. Mustang herds are now protected under United States law.

I wanted to make my picture of the mustang distinctive by placing the horse in its natural American West environment, so while I have kept the horse's stance quite simple, the intricate detail of the native foliage really brings the picture to life. You can use either thick paper or canvas to paint on; I chose to make this study on 300gsm (140lb) Bockingford watercolour paper, which is robust enough to cope with thick paint and is able to tolerate water without cockling.

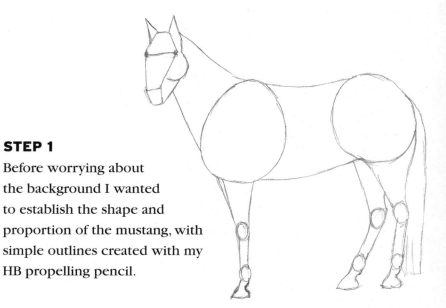

STEP 1

Before worrying about the background I wanted to establish the shape and proportion of the mustang, with simple outlines created with my HB propelling pencil.

STEP 2

I refined the outline and began to fill in the foliage around the horse's legs and hooves, again using my propelling pencil to maintain a fine line. This foliage detail looks complicated, but the mass of leaves and stalks is just made of many small and simple interlocking shapes. This part took a little time to lay in, but working hard on the vegetation at this point makes the painting stage a lot easier.

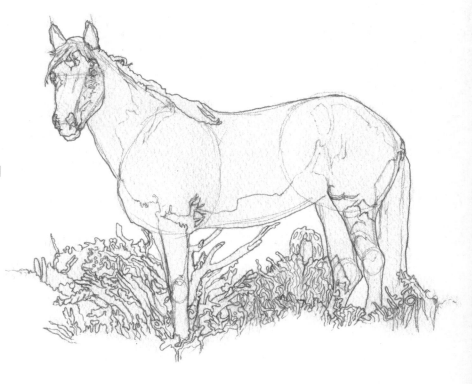

STEP 3

I mixed a mid-grey tone using black and white acrylic paint and thinned it with a little water to make the paint smooth and evenly textured. Using a small flat brush, I blocked in the darkest shadows. Locating areas of tone is easy if you look at your reference image through half-closed eyes as this helps you to ignore specific detail and just interpret the picture tonally.

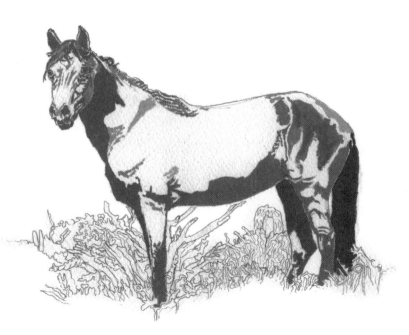

STEP 4

I wanted to use a stippling technique to apply the top layer of paint. Acrylic is perfect for this because it is heavy-bodied enough to create texture on the surface of the paper. I mixed light, dark and mid-tone paint on my palette using my round No. 1 brush, then used small dabbing motions to apply the paint to the paper, darkening the shaded areas, establishing the mid-tones and leaving the white of the paper showing to denote the highlights. This technique not only establishes tone and form in the horse but also evokes the texture of the coat. I added pure white paint to some areas that needed further highlight. Since the paint is fast-drying and water-resistant it can easily be painted over and corrected, so highlights can be added over dark areas – a crucial difference in working methods from those used in watercolour.

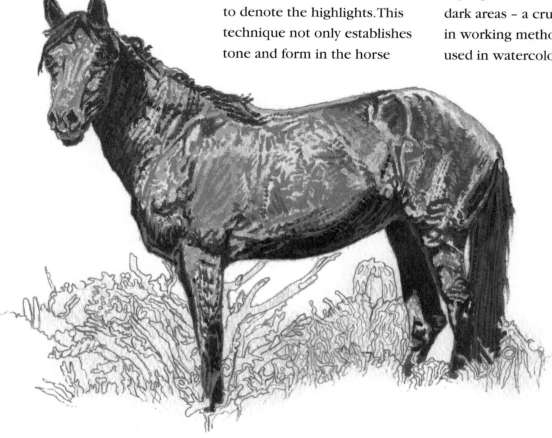

STEP 5

In the final stage, I continued to use this stippled application of paint when painting the foliage. Using the same round brush I varied this by marking out the stalks of the plant surrounding the mustang's front legs. This breaks up the foreground and adds interest to the composition.

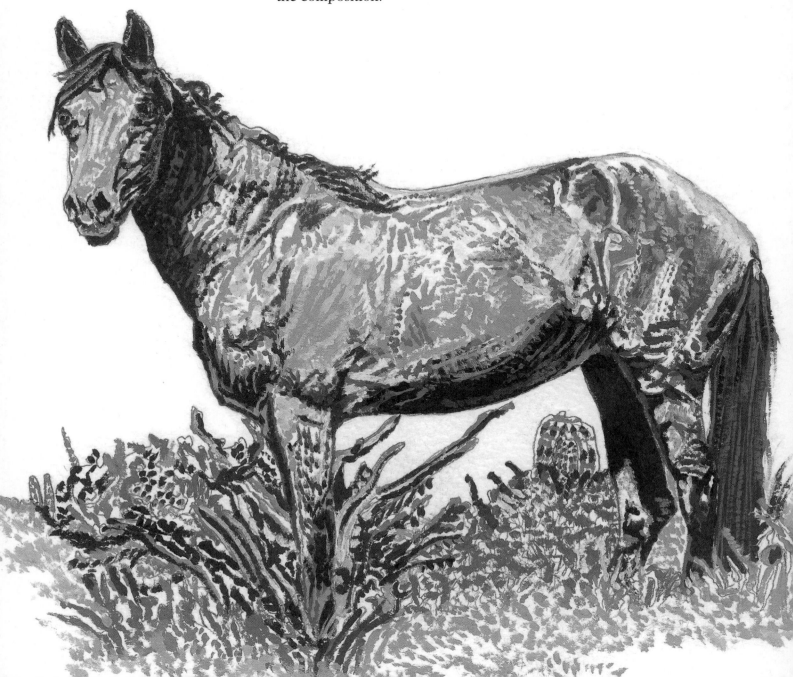

ACRYLIC PAINT TECHNIQUE

Easy to handle and fast-drying, acrylic paint is a great medium for creating more densely pigmented pictures than can be achieved with watercolour. It is ideal to practise with before moving on to the more technically complicated oil paints and creates a very similar outcome visually. The pigment is suspended in an acrylic polymer emulsion, and this plastic base means that the paint can simply be thinned with water like watercolour to create translucent washes. Alternatively, you can use it thickly to create textured surfaces. When dry the surface becomes hard, slightly shiny and water-resistant, so unlike watercolour you cannot blend the paint again retrospectively.

Acrylic can be applied to thick watercolour paper or stretched canvases, using thick or thin brushes to create bold strokes or intricate detail.

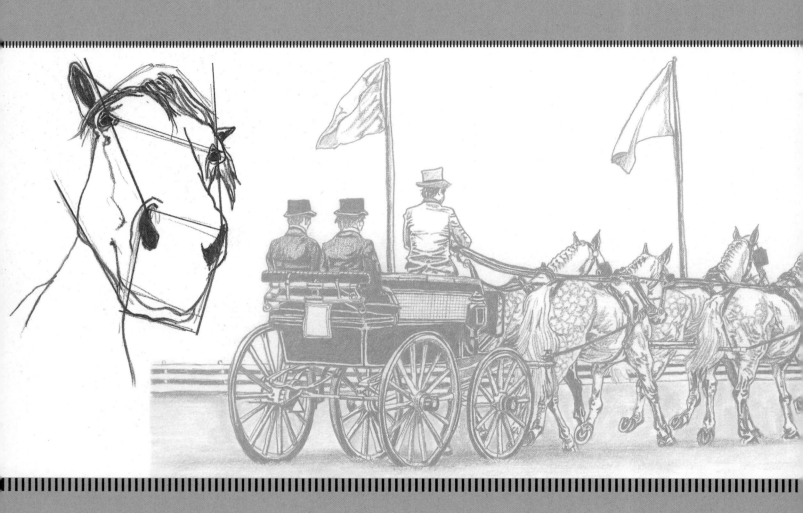

Composition and Perspective

Now that you have got to grips with how to draw the horse in all its variations of form and movement, you can begin to create compositions and explore perspective techniques that give the illusion of three dimensions in your drawing. While some novice artists find the idea of dealing with perspective daunting, the rules that govern it are not difficult to grasp and applying them correctly in your compositions will help you to create depth and establish a visual relationship between your horses and their environment. In this chapter we shall look at single- and two-point perspective and how to use them.

SINGLE-POINT PERSPECTIVE

Single- or one-point perspective is used to construct objects that are either directly parallel or directly perpendicular to the viewer's line of vision. So we can use single-point perspective to construct a road or path diminishing away from us into the distance, for example, or to draw buildings where a wall is directly facing the viewer.

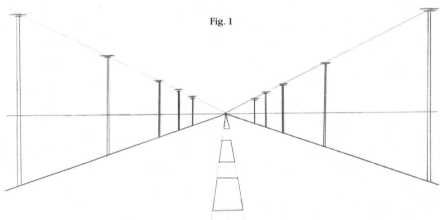

Fig. 1

Start by drawing a horizon line, which will always be at your eye level. You can experiment with high or low viewpoints, but at first it is probably best to choose a normal viewpoint – that is, how an adult person sees the world on an everyday basis when standing up. This will give a realistic result in your drawing.

Next, establish a central point on your horizon line – this is the vanishing point. Then draw two lines representing a road in front of you, narrowing to meet at the vanishing point. You can see from Fig. 1 how a road drawn using single-point perspective appears to recede into the distance. I drew two more lines above the edges of the road

and used these as guidelines to draw in vertical lines representing telegraph poles. Notice how the poles decrease in size the further they are from the viewer. I also added two more central lines to help me draw in the central road lane dividers; these road markings decrease in width as they recede into the distance.

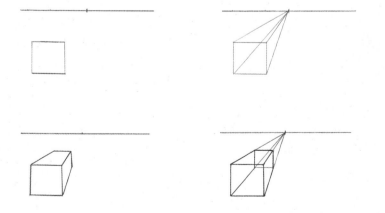

Fig. 2 shows how to construct a cube using single-point perspective. Draw a square below and to the left of your vanishing point on the horizon line, then draw lines from each corner of the square to the vanishing point. Now draw in vertical and horizontal lines to make a second square behind the first, representing the back of the cube. You can see in this stage of the diagram how the cube appears to recede into the background. Now you can erase the internal lines and the lines drawn to the viewpoint so that the cube becomes a solid three-dimensional object.

Fig. 2

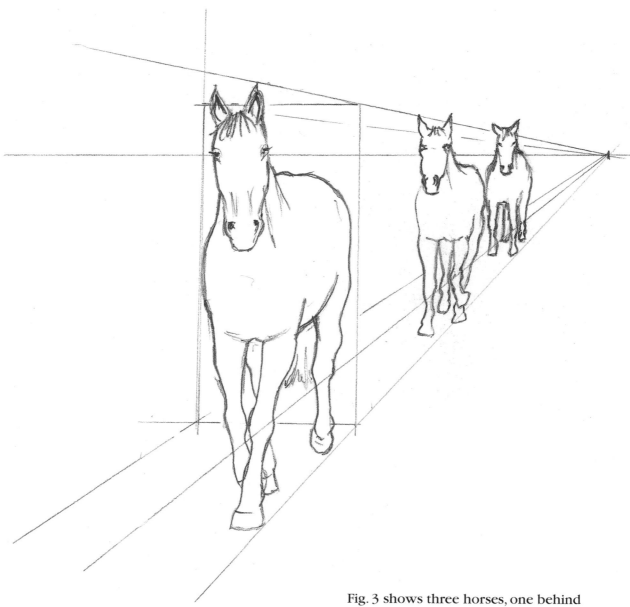

Fig. 3

Fig. 3 shows three horses, one behind the other, drawn using the single-point perspective method. You can see the foreshortening present in the bodies of the horses. Also notice how the horse at the rear is about a quarter of the size of the horse at the front. This size difference helps to establish the illusion of distance – the eye is fooled into thinking that the horses are walking in file, one behind the other.

TWO-POINT PERSPECTIVE

For objects that are presented at an angle to the viewer, you will need to use two-point perspective to construct your drawing. Two-point perspective has two vanishing points which are marked on the horizon line and lines are drawn to both of these points rather than just to one, as in single-point perspective.

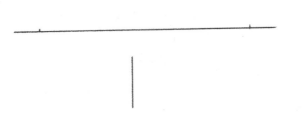

STEP 1

First draw your horizontal horizon line and mark two points at each end on this line. Now draw in a vertical line roughly halfway between these two points.

STEP 2

Add two lines from each of the vanishing points to connect with the top and bottom of the central vertical line.

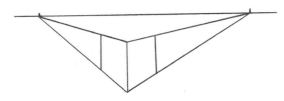

STEP 3

Next draw two more vertical lines each side of this central vertical. You can now see the cube taking shape – we are presented with the corner of the cube with the two sides receding into the distance.

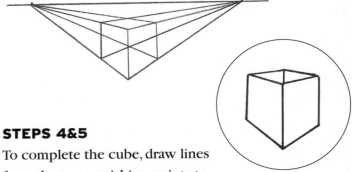

STEPS 4&5

To complete the cube, draw lines from the two vanishing points to the top and bottom of the vertical lines each side of the initial central vertical. You can now erase the construction lines so that you are left with a solid opaque cube.

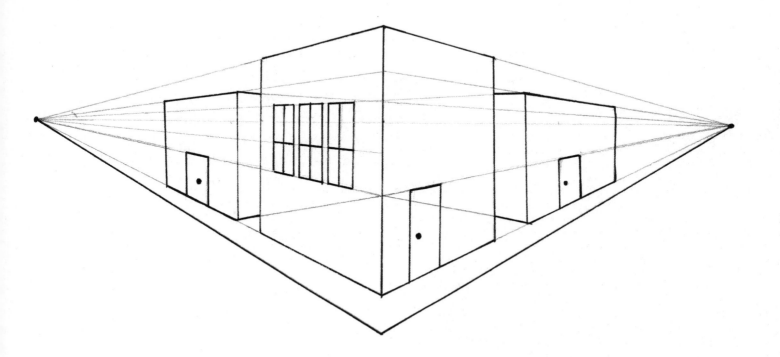

When you are drawing buildings at an angle to the viewer in your compositions, two-point perspective will ensure that the angles are correct to convey the recession of the walls and roofs into the background (see above). It is also useful for planning your horse drawings. The illustration below shows the horse seen at an angle, drawn within the cube. The hooves are roughly laid out following the four corners of the rectangle making up the base of the cube.

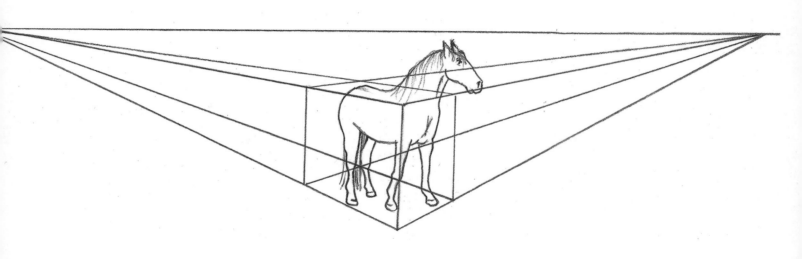

DIFFERENT VIEWPOINTS

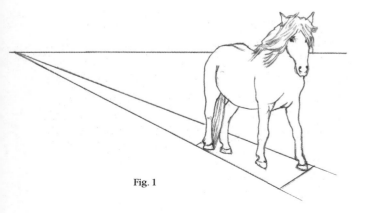

Fig. 1

Choosing extreme viewpoints can add drama and interest to your final compositions. Fig. 1 shows a horse drawn from a normal viewpoint; compare this with Figs 2 and 3 where the horse is seen from above and below. These extreme viewpoints can be used in a composition to emphasize the position of the horse in its surroundings. For example, if you are drawing a mountainous landscape, using a very high or low viewpoint will place your horse high up on the summit of a hill or low down in a valley.

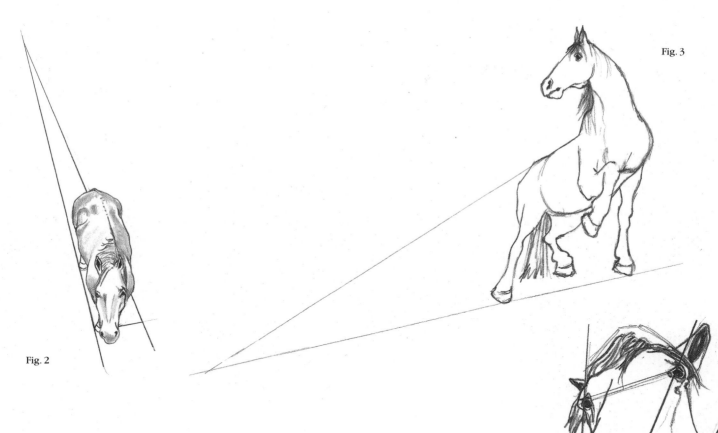

Fig. 3

Fig. 2

Fig. 4 shows a horse's face drawn from an extremely low viewpoint. The coffin shape has been used to construct the form of the face. The view causes extreme foreshortening in the length of the face from the muzzle to the brow, resulting in a rather comical image.

Fig. 4

COMPOSITION TECHNIQUES

There is no strict formula for creating an effective composition, but being aware of the components that make a drawing interesting will help when you are starting to think about creating a finished piece. The best compositions do not just happen by accident or by making an exact copy of a photograph – they are designed to attract and hold the eye of the viewer.

Using the perspective and proportional techniques we have discussed in this book will establish a formal relationship between the horse or horses and the surrounding scene. Balance and harmony is essential to make the composition work and your drawing page should be planned out to enhance the objects it contains.

Don't let yourself be ruled by the quest for over-detailed realism. When planning the composition, roughly sketch your forms lightly so that lines can easily be changed. Your eye is the best tool to tell you whether your initial sketched composition works. If the image grates on your eye and evokes a negative emotional reaction, then something is wrong.

Preliminary sketches can easily be modified until they 'feel' right. It is best not to put in detail until you are completely happy with your sketched-in composition, otherwise you may be reluctant to abandon the work you have done and choose instead to press on with a drawing that is never going to be as good as it should be.

Making a composition for a drawing is a bit like telling a story. Decide what you want the picture to say and what mood you are trying to convey – perhaps action, or serenity, or precision and control. Think about what marks and tones evoke each mood: subtle tonal contrast and smooth blended pencil can conjure peace and calm; vigorous sketchy lines are good for establishing movement; stark contrast between dark and light makes an image dramatic.

The four compositions that follow on the next few pages have been broken down into step-by-step stages. The work shows that with a simple yet carefully planned initial sketch you can easily create beautifully detailed harmonious compositions. I have chosen a variety of subjects to show how to evoke a specific mood with the arrangement of the elements of a picture and which type of marks to use when adding detail to make the finished drawing.

THE DRESSAGE ARENA

Dressage is a French term, which simply means training. It is a very disciplined and controlled equestrian sport, which depends on close and harmonious interaction between the horse and rider. The dressage arenas are usually very formal, neat and orderly. I wanted to evoke this restrained and formal tradition in my composition. Obviously I needed the horse and rider to be the focal point of the drawing, but I also wanted to create quite a theatrical architectural backdrop to enhance the feeling of precision and controlled beauty that embodies the essence of a dressage horse's movement.

STEP 1

Using my HB 0.5mm propelling pencil, I started by laying in the verticals and horizontals of the buildings and the arena to establish the framework of the background. I sketched in the horse and rider in the centre of this linear framework. The composition is balanced above by the form of the building and below by the perimeter of the dressage arena. I chose a classic dressage pose when drawing my horse – the front leg is extended straight and the other three legs are bent, establishing a gentle spring in the step.

STEP 2

Once the basic structure of the composition was established and I was happy with the angles of the lines, I began to lay in the linear detail. The building in the background is in a traditional Neo-Classical style, with columns supporting terraces and a domed roof. I made sure that I kept the verticals of the columns and the windows in line with the verticals of the walls to evoke the harmony of the building's structure. Using a small ruler helped to keep these lines correct. I elaborated on the lines of the fence around the arena and added the plant containers. Finally I refined the outline of the horse and rider and erased all the initial guidelines.

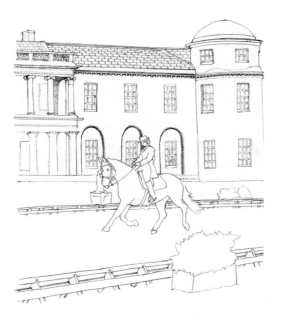

STEP 3

I added the details of the building so that it began to take on a more three-dimensional presence. I used a ruler to mark in the lines of the tiled roof and the frames of the sash windows.

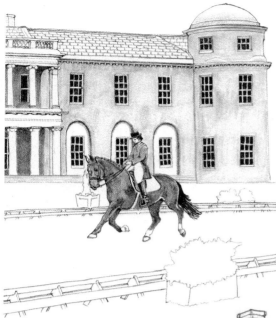

STEP 4

Next, I used a soft 4B pencil to shade in the windowpanes and the shadows behind the columns. I lightly shaded the walls of the building and blended this smoothly, using a tortillon. For shading in the horse and rider I used quite dark tones so that they are really thrown into the foreground of the image and are established as the main focus of the composition.

STEP 5

The final stage was to work on the details of the foreground. I shaded and smudged texture into the surface of the dressage arena and used short vertical lines to describe the grassy ground in front of it.

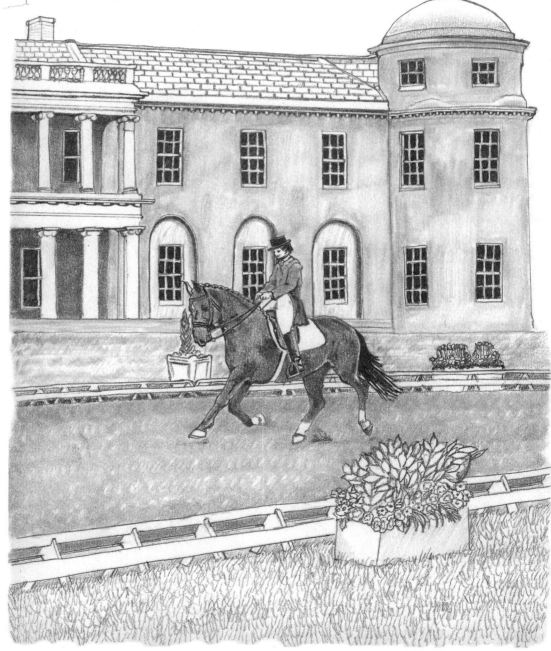

THE HACK

As a hack entails gentle cross-country riding, it is a fun day out with the horses for people of all ages. I wanted to depict a sleepy country lane surrounded by foliage, typical of the trails followed on hacks. The horses generally progress in file behind a lead horse, for which the single-point perspective we looked at earlier in the chapter would be needed (see pp.94-5).

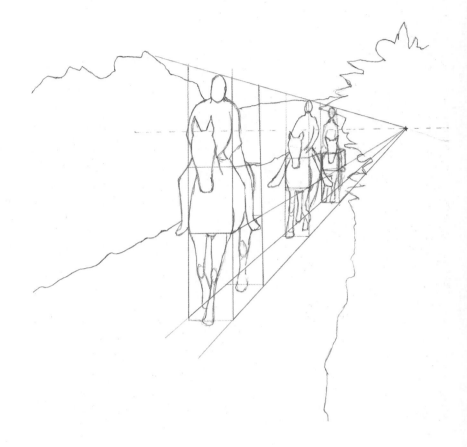

STEP 1

First, using my HB propelling pencil, I marked in my horizon line and put a cross on this line to place the vanishing point. I then drew a line radiating from this point to establish the path for the horses to walk upon. The guideline radiating upwards marks where the top of the rider's heads should be drawn. I roughly drew in some lines to suggest the foliage bordering each side of the path and in the distance.

STEP 2

Once I was happy with the composition, I refined the outline of the horses and riders and erased all the preliminary working.

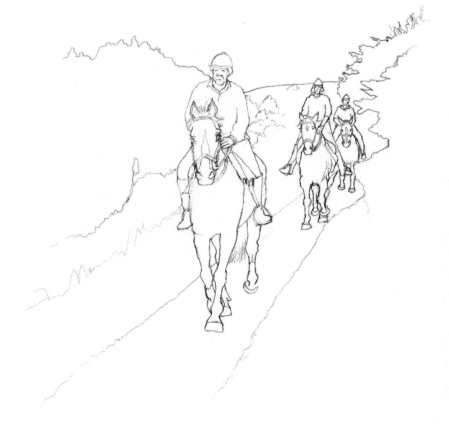

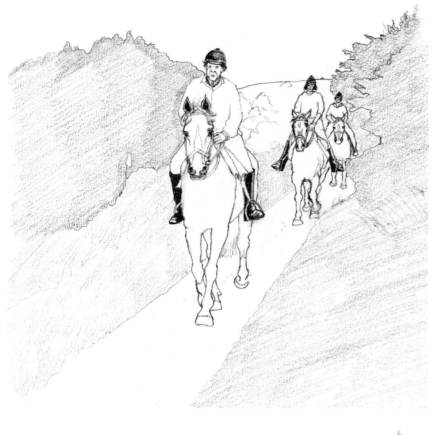

STEP 3

Next I shaded in the black boots and hats of the riders, using a very soft 8B pencil. I then roughly laid in the base tone of the foliage at the sides of the path.

STEP 4

I used the tortillon to blend and add texture to the foliage shading, then started to plot the darkest tones on the body of the lead horse, using the 8B pencil.

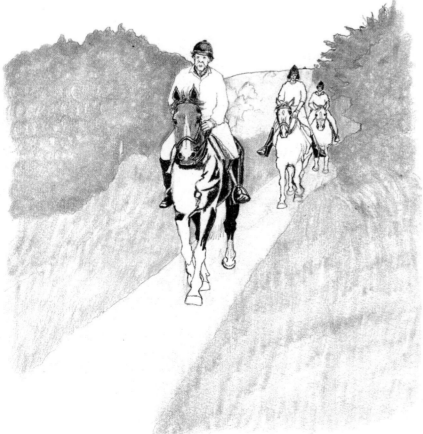

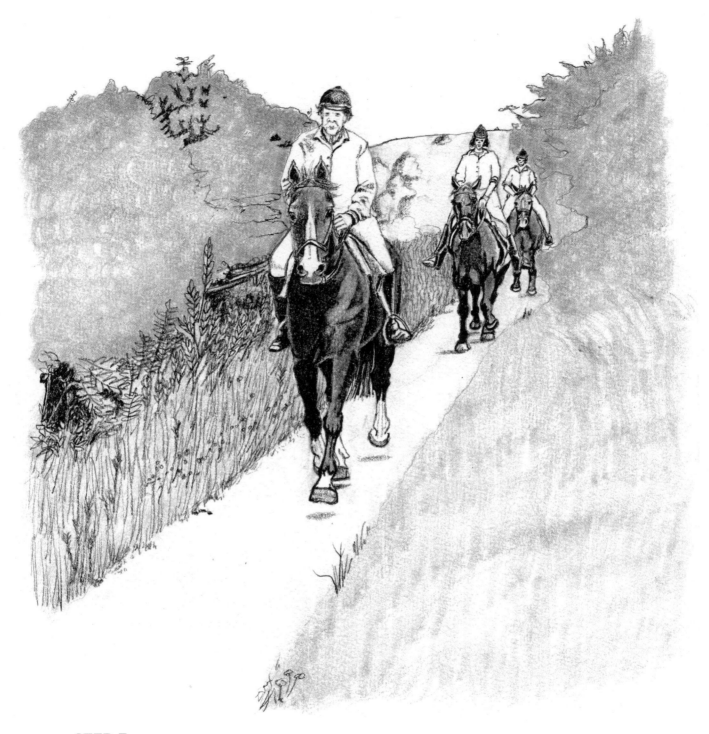

STEP 5

It is important to bear in mind the direction of the light source so that when you are laying in the shadows you maintain consistency in the overall feel of the whole composition. After adding the dark shadows to the first horse I made sure that the other horses were shaded in the same areas, so it is clear to the viewer that the sun is shining down from the right-hand side of the picture. I then began to add details to the foliage on the left-hand side of the path, using my HB propelling pencil to ensure a fine line.

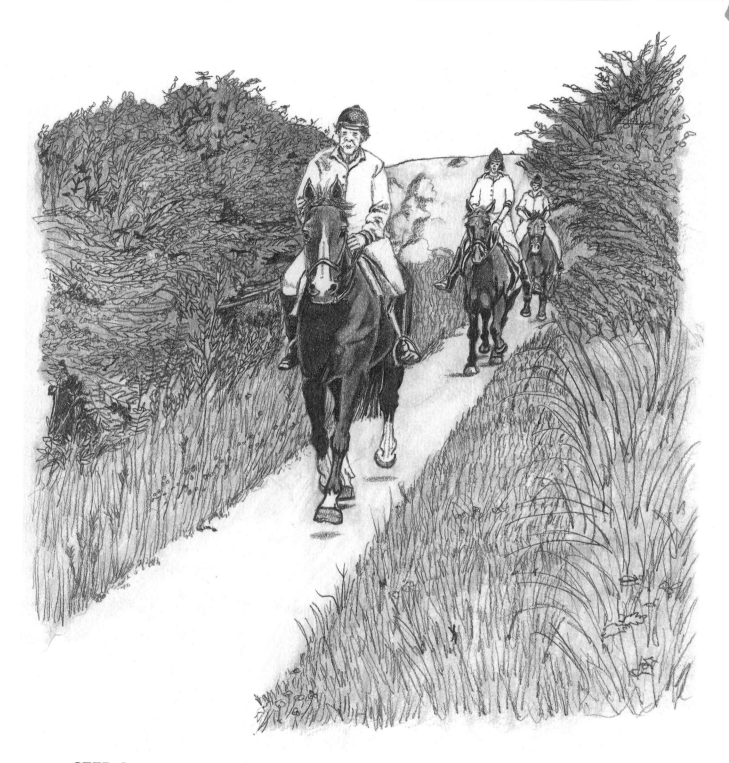

STEP 6

The last stage was to complete the process of filling in the foliage detail. As you have seen previously in the drawing of the hunter on pp.58–9, while drawing leaf and grassy detail is quite time-consuming it is very simple and definitely worth working on; it gives your pictures texture and interest and provides a beautiful backdrop for the subject of any composition.

THE STABLE

In this composition I wanted to evoke the drowsy, calm feeling of a stable, which provides a warm, safe environment for a horse to feed and sleep. To achieve this, I thought it was important to establish the line of the walls and roof to make it clear we are looking at an interior. I placed the three horses in the centre of the drawing. Their relaxed poses – the suckling foal and the foreground horse which is in the process of extending its neck to the ground – establish an overall feeling of peace in the composition.

STEP 1

Using my HB propelling pencil, I began by drawing in the horizontals of the back wall, the timbers of the roof and the vertical lines to show the location of the windows. I then sketched in the group of horses.

STEP 2

I started to work on the perspective of the drawing to describe the three-dimensional interior of the stable. I added curves to the top of the windows and an inner vertical line to show how the windowpanes are recessed into the wall, then added straw texture to the floor of the stable and lines to show hay in the feeding basket on the wall. Finally I refined the outlines of the horses and erased the preliminary working.

STEP 3

I used a ruler to mark in the lines of the bricks in the wall and added light shading to the whole of the wall surface. After adding in the poles of the hay basket, making sure I maintained the same angle along the whole length, I began to shade the poles, using a 4B pencil to emphasize their solidity and the spaces between them.

STEP 4

After laying in soft shading using a 2B pencil which I then blended to a smooth finish all over the background of the picture, I used a hard eraser to lift out the rectangular shapes of individual bricks within the lines I had drawn on the wall. I finished shading in the poles of the hay basket with the 4B pencil and added a few random lines between the poles using the propelling pencil to show the hay protruding through. Then I laid in the darkest tones on the body of the foal using a 4B pencil.

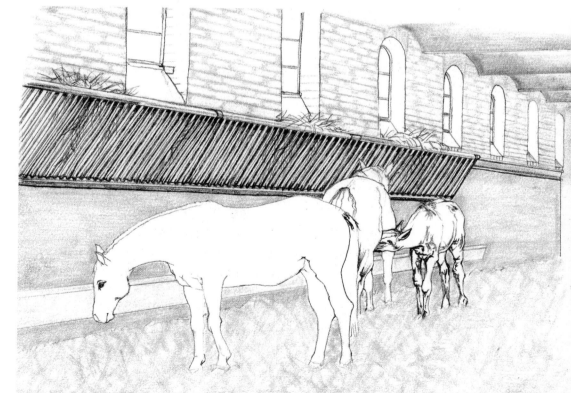

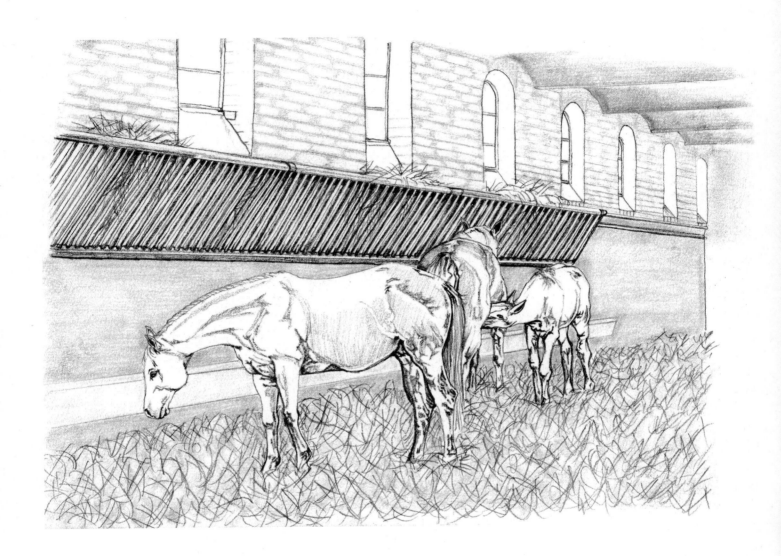

STEP 5

Next I added shading to the other two horses, using a 4B pencil for the darker tones and a slightly harder 2B for the lighter ones. I then worked on creating the texture of the straw on the floor by using the propelling pencil to create random scribbly lines over the area.

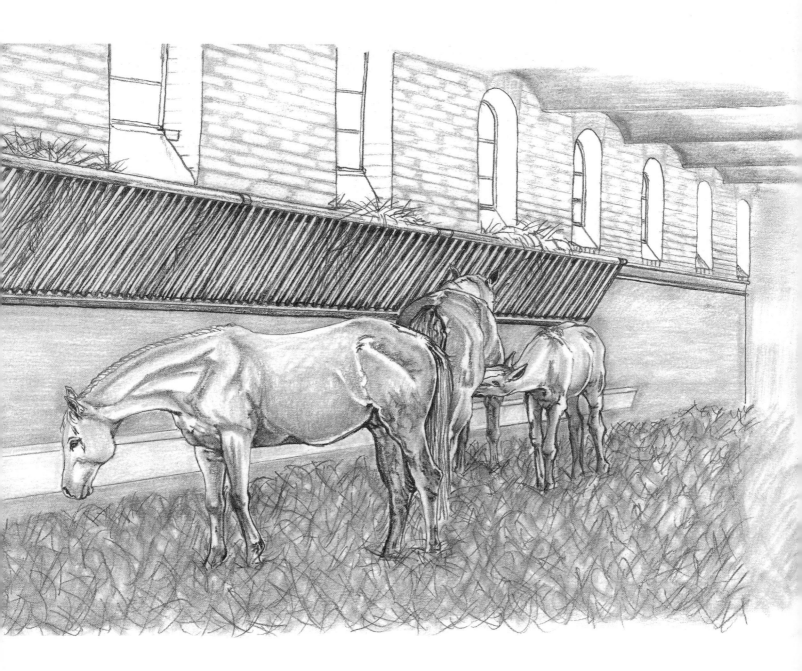

STEP 6

Finally, I blended the shading on the bodies
of the horses. I wanted a fairly subtle tonal
contrast in the overall image, so I made sure
that there were no stark differences between
dark and light. I then smudged the lines of
the straw to give it a softer textural quality.

THE CARRIAGE

Horses have been used to pull a cart or carriage over many centuries, so they have evolved to be naturally comfortable in their role as harnessed animals. In this composition I wanted to make clear the reins linking the four horses with the carriage and the drivers. These reins symbolize an important connecting line that unifies the composition. The background is very simple; since the carriage and horses make a relatively complex arrangement of shapes, adding a complicated background would only confuse the eye of the viewer and detract attention from the subject. I did, however, add the flag poles behind the carriage group so that the strong horizontals in the composition are balanced by verticals.

STEP 1

Using my HB propelling pencil, I began by plotting horizontal lines to help me when drawing in the two horses nearest the viewer and the near side of the carriage and wheels. I then constructed a three-dimensional cuboid shape as the basic structure of the carriage, adding the three people into this shape. Next I drew in the two far side horses, placing them slightly behind the animals nearer the viewer, and added in the line of the reins to unite the components of the group.

STEP 2

Establishing the detail of the harnesses and bridles on each horse and the attachments to the reins came next, then I began to refine the outlines of the horses and erased the preliminary lines. I elaborated on the box shape of the carriage and made sense of the relationship between the wheel and the base of the carriage. Adding top hats and smart coats to the driver and groomsmen shows the formality and history behind the discipline of carriage driving.

STEP 3

Next I shaded in the reins, harnesses, blinkers and the body of the carriage, using a soft dark 4B pencil.

STEP 4

I worked on shading detail into the wheels, making sure their spokes followed the perspective of the composition. Using the 4B pencil, I then laid in the darkest tones of shadow on the two groomsmen sitting at the back of the carriage and added straight cross-hatching to the panel of the seat rest behind the driver.

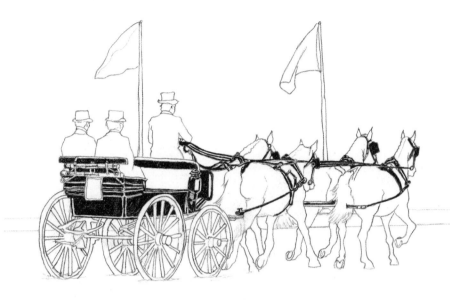

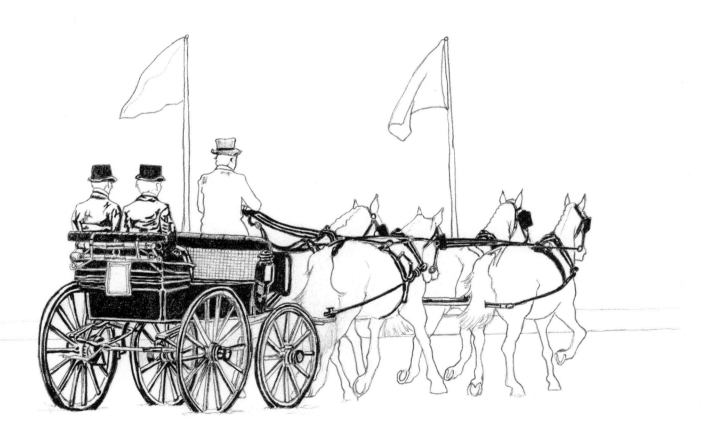

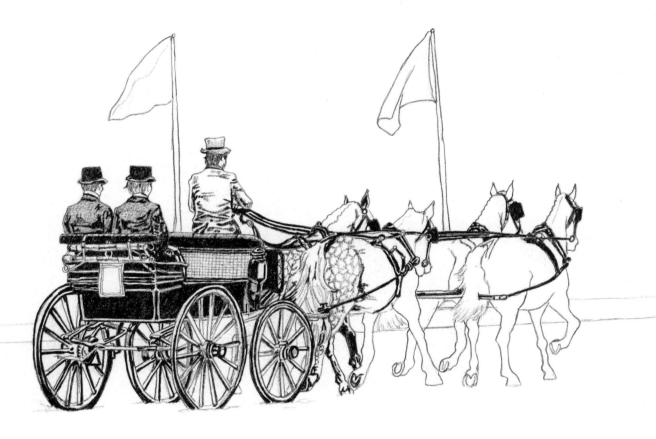

STEP 5

After softly shading and blending the coats and hats of the driver and groomsmen I began to add the dappled pattern on the horses' rumps, using a light soft 2B pencil and making small interconnecting ring shapes.

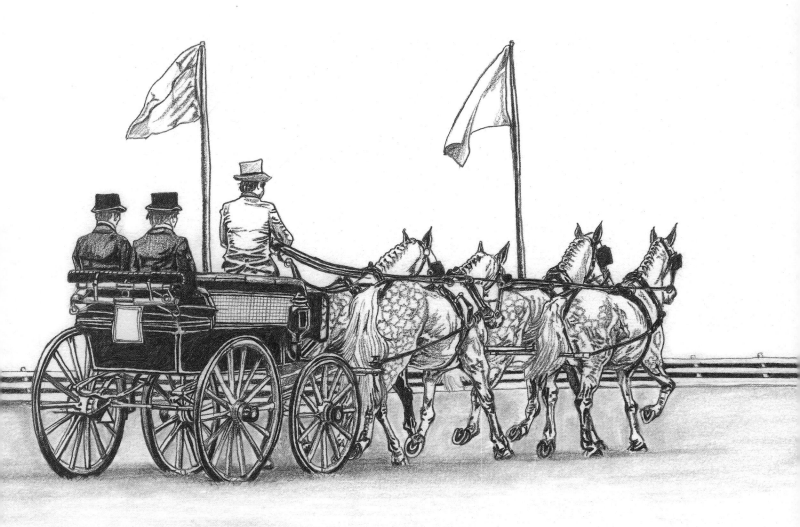

STEP 6

Next I shaded in between the slats of wood on the fence along the edge of the course. With the 2B pencil I added soft shading to the flags to evoke their fluttering motion and finished the dappling on the bodies of the four horses. Lastly I used the tortillon to smudge some soft shading beneath the carriage and horses. This helped to locate and ground the group within its setting.

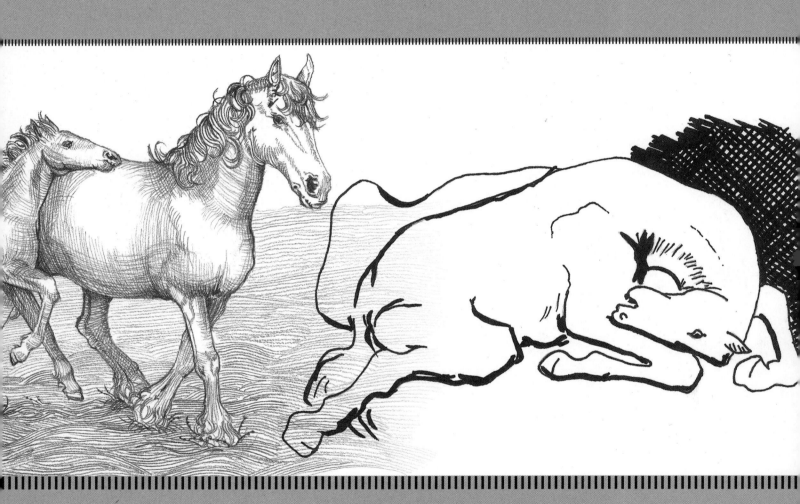

Developing Your Own Style

Your own artistic style is something that will evolve over time the more you draw. However, studying the work of other artists and thinking about their techniques while creating your own drawings will help this evolution to progress. Look in particular at drawings and paintings by artists who are renowned for their equine studies; note down elements of their approach that you found especially interesting, then try to combine techniques from different artists in one project.

The horse has been a subject for the artist over many centuries, since its presence was integral to the lives of so many different people – as a means of transport, as an agricultural work horse, as a war horse or simply as a riding horse for sport. This close relationship between human beings and the horse has given us a wealth of paintings, drawings and sculptures by notable artists. In this chapter we shall look at the work of some of those artists and examine what makes their style unique, then embark on composition studies that draw upon their techniques.

ALBRECHT DÜRER

A German artist working from the late 15th to the early 16th century, Dürer is famous for his beautifully refined engravings and woodcuts of religious scenes. He was also inspired by close observation of nature and was one of the first European artists to regard landscape as a subject in itself.

Here I have copied one of his horse engravings, entitled *The Large Horse*. The image does not appear to be constructed according to notions of the correct proportions of the horse; rather Dürer uses a very individual, stylized approach. The extreme foreshortening in the body of the horse, exaggerated musculature and curling mane and tail make the image very distinctive. The aspect of Dürer's style that especially appeals to me is his fine control of cross-hatched lines that describe not only light and shade but also the contours of the form, the lines curving to emphasize the bulge of the belly and the cylindrical shape of the legs. The technique makes the form of the horse look very solid and real.

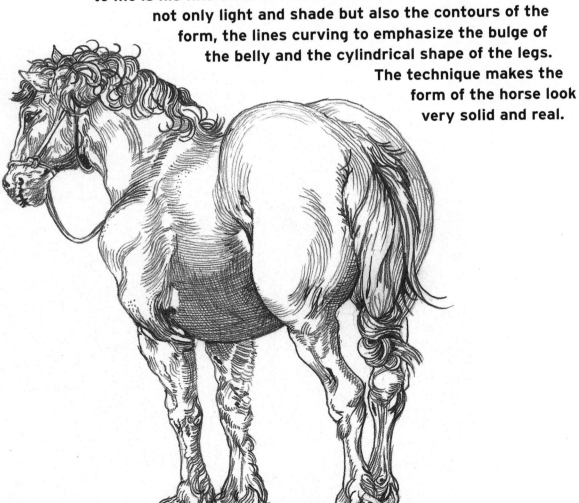

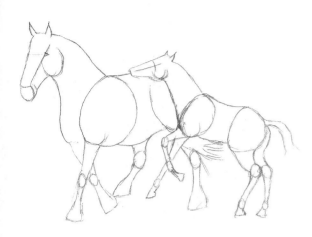

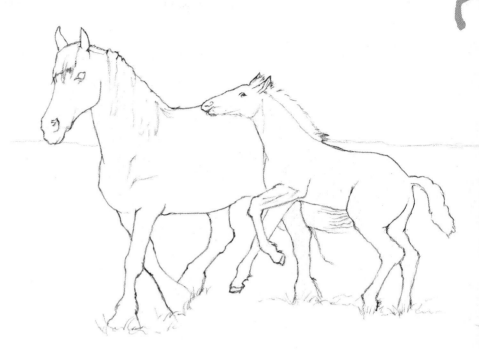

Mare and foal

I wanted to translate the clarity and control that can be achieved with Dürer's engraved line into my own work, so I made a study of a mare and foal playing in a field employing this cross-hatching technique. I used a standard HB propelling pencil for this project as it maintains a sharp fine point to the pencil lead.

STEPS 1 AND 2

First I drew my sketch of the mare and foal, maintaining the usual approach of making the initial outline drawing from the primary shapes.

STEP 3

Next I added the detail of the manes and tails, borrowing Dürer's approach to describing the strands of hair by making precisely curled lines that fit together to produce an almost sculptural appearance.

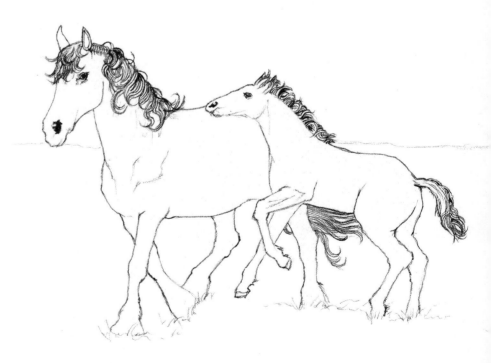

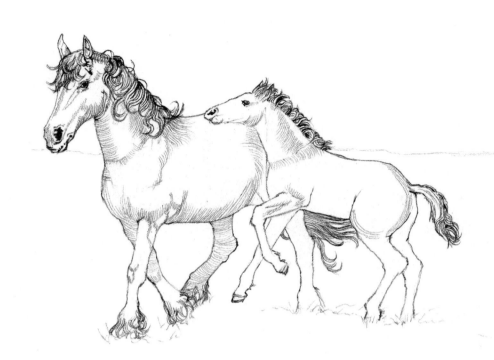

STEP 4

As I began adding closely spaced curved lines to the bodies, the three-dimensional forms of the mare and foal started to take shape.

STEP 5

I then added cross-hatched lines to suggest darker shaded areas, making sure these lines also followed the contours of the forms.

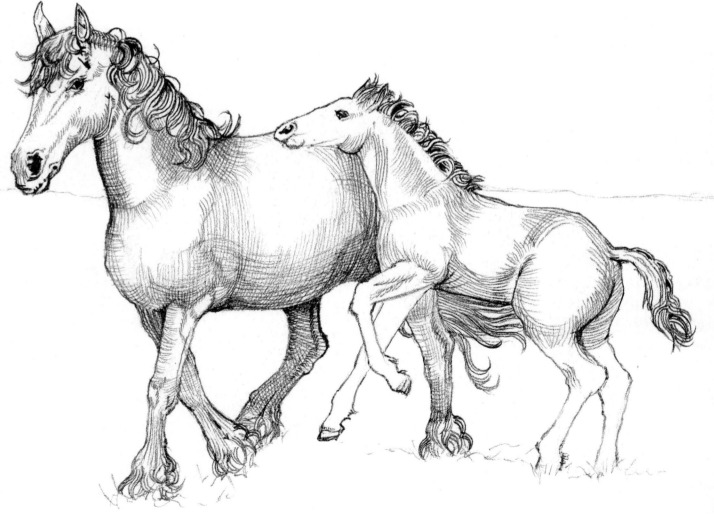

STEP 6

I continued to develop this cross-hatching and also darkened the outlines of the animals so that they really stood out.

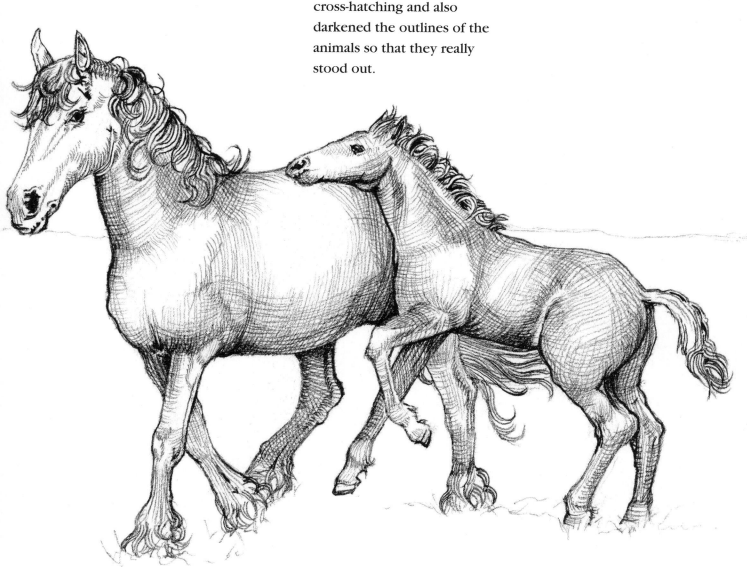

STEP 7

Finally I worked on the
background, using the same
closely spaced lines. I put
more pressure on the pencil
in the foreground lines and
used a lighter touch in the line
describing the background; this
establishes the idea of spatial
recession.

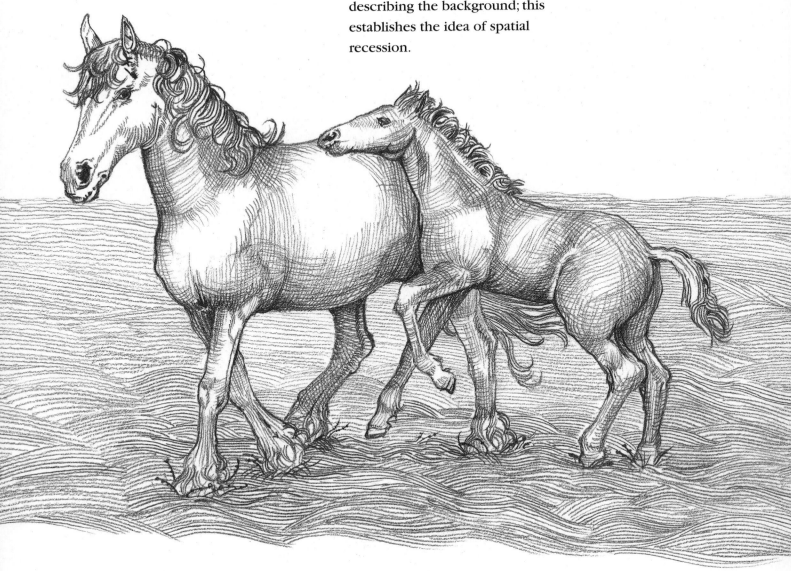

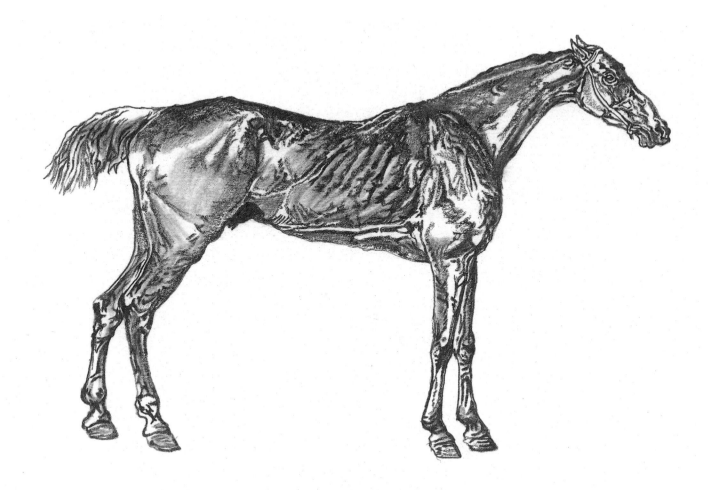

GEORGE STUBBS

Probably the most famous horse painter of all is George Stubbs, who worked throughout the latter half of the 18th century. He was fascinated by anatomy and even made a book of engravings entitled *The Anatomy of the Horse*, published in 1766. When looking at the detailed studies in this book, you can see that he spent much time dissecting and drawing the animals so that he achieved a thorough knowledge of the anatomical form of the horse. This interest is clear in his finished paintings.

I drew a copy of his painting *Rufus*, made in the 1760s. The skeletal structure is very clear beneath the skin of the animal and I emphasized this anatomical expression in my own study, using tonal contrast to evoke the ribcage and bulging muscles of the shoulders and rump.

ALFRED MUNNINGS

An understanding of equine anatomy was also very important to Alfred Munnings - it gave him confidence in his ability to create the form of the horse and allowed him to experiment with freedom and boldness in his mark-making. He worked mainly between the First and Second World Wars at a time when Modernist art by Picasso and Cézanne was emerging - a movement that he thoroughly detested. While his brush strokes are free and loose, his forms are constructed according to proportional rules and his compositions follow in the footsteps of his greatest idol, George Stubbs.

I copied the Munnings painting entitled *A Bay Horse in a Landscape*, using oil pastel to make the study because I felt that it was the best medium to make the bold marks characteristic of Munnings' work. The proportions of the horse are perfectly correct but there is none of the precision of detail that defines the Stubbs style. His brushstrokes are about speed and immediacy.

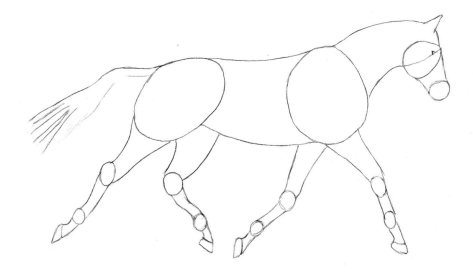

Trotting horse

Then I made my own study of a trotting horse, imitating the Munnings style. Again I used oil pastel because this medium does not allow you to get too caught up with fine detail but rather allows you to concentrate on tonal contrast.

STEP 1

I chose this uncomplicated side view of the horse trotting because it provides a clear outline within which to make the bold marks characteristic of Munnings' style. I used the HB propelling pencil to sketch in this outline.

STEP 2

Once I was sure that my sketch was correctly proportioned I refined the outline and added detail to the mane.

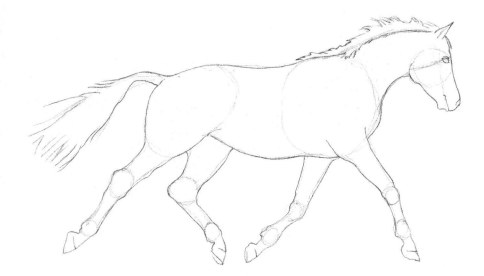

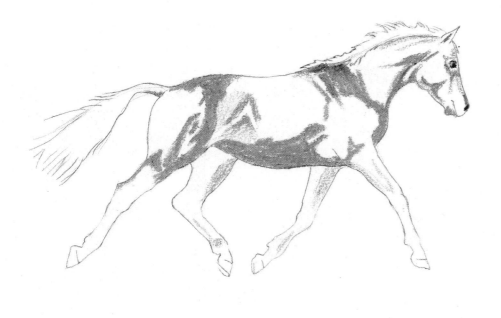

STEP 3

Using a mid-grey pastel, I laid in the darker shadows. A good way of making sure you don't get preoccupied with detail when working from a photograph is to look at the image you are copying through half-closed eyes. This eliminates the intricacies of the image and helps you to establish areas of tonal contrast.

STEP 4

Next I darkened the grey tones with black pastel. These darker tones begin to evoke the skeletal and muscular forms of the horse beneath the skin. I also used the black pastel to establish the dark tones of the flowing mane and tail.

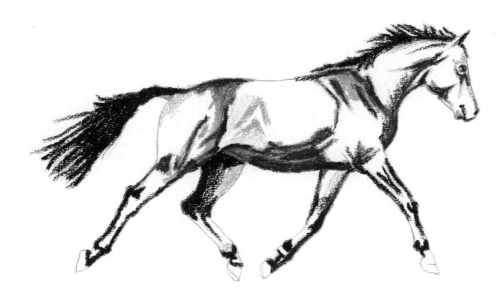

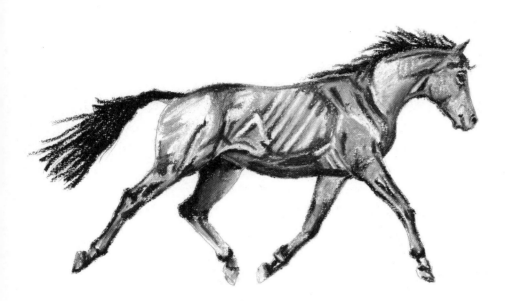

STEP 5

I began to blend the grey and black tones into each other and put in the highlights with a white pastel. I also added bold lines to the horse's chest to indicate the ribcage.

STEP 6

Finally, I added texture to the ground by mixing grey and white pastel on the area beneath the horse's hooves. Adding the shadow of the horse established the connection between the animal and its surroundings.

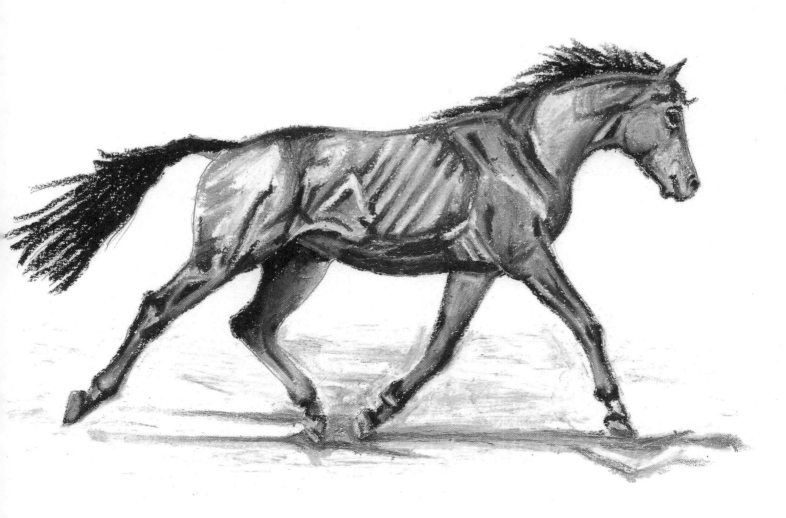

FRANZ MARC

Franz Marc is one of the best-known modern horse artists. Marc felt animals had a natural purity that humans no longer possessed and his preoccupation with painting animals, particularly horses, stemmed from his desire to regain contact with his innate spirituality. This psychological approach to depicting the horse departs from the traditional realist approach to painting. His paintings are, therefore, not about rendering an anatomically correct horse; for him horses become symbols of the simplicity that humans have lost in the process of their emotional evolution. The forms are bold, simplified and dynamic and evoke something deeper than just the visual appearance of the subject. Marc spent time in France and was greatly influenced by Impressionism, a style that is clearly evident in his loose and expressive brushwork. I used oil pastels to make this copy of his 1912 work *Little Yellow Horses*. The rhythmic curves of the forms convey harmony and peace. Marc teaches us that while the rules of draughtsmanship are important you should not allow visual realism to restrict you. Evolving your style is about experimentation and pushing back the boundaries of existing art to create new and exciting images.

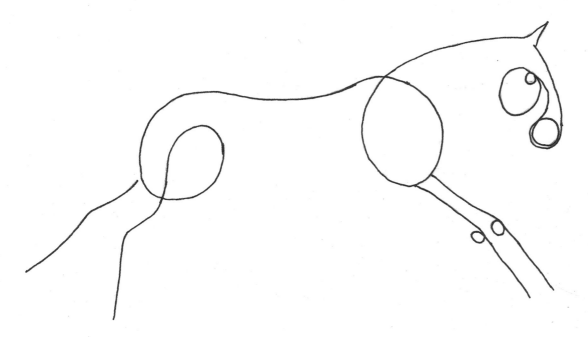

After studying the work of Franz Marc and other modern artists, I started to experiment with different abstract approaches. Taking inspiration from the loose and bold style of Marc, I made two simple studies to capture the essence of the form of the horse. The first study of a horse in mid gallop is made up of a single line, which uses loops and curves to describe the contours of the horse.

The second depicts a foal suckling from its mother. I wanted the picture to show the close emotional relationship between the mother and baby. The two animals are created using a single line and the front legs belong ambiguously both to the foal and the mother at the same time. The simplicity of this abstract linear approach perfectly evokes the unification of the two animals during suckling.

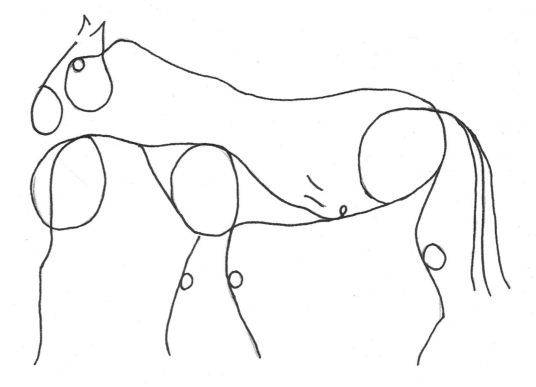

Index